The Tao of Photography

SEEING BEYOND SEEING

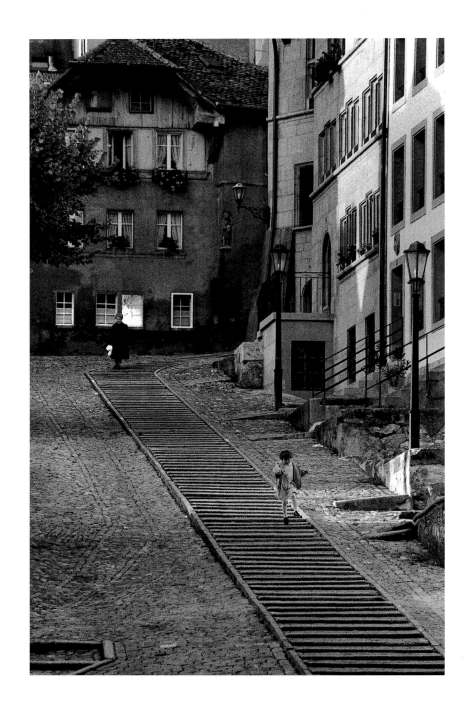

Philippe L. Gross, *Down the Stairs*
Fribourg, Switzerland, 1987

The Tao of Photography
SEEING BEYOND SEEING

Philippe L. Gross, Ph.D.
S. I. Shapiro, Ph.D.

With a Foreword by Duane Preble

Ten Speed Press
BERKELEY TORONTO

Ten Speed Press
P.O. Box 7123
Berkeley, California 94707
www.tenspeed.com

Distributed in Australia by Simon and Schuster Australia, in Canada by Ten Speed Press Canada, in New Zealand by Southern Publishers Group, in South Africa by Real Books, and in the United Kingdom and Europe by Publishers Group UK.

Design by Catherine Jacobes Design, San Francisco

Library of Congress Cataloging-in-Publication Data
Gross, Philippe L.
 The Tao of photography: seeing beyond seeing / Philippe L. Gross,
S.I. Shapiro; with a foreword by Duane Preble.
 p. cm.
 Includes bibliographical references and index.
 ISBN-10: 1-58008-194-0
 ISBN-13: 978-1-58008-194-8
 1. Photography--Philosophy. 2. Taoism. 3. Photography, Artistic.
I. Shapiro, S.I., Ph.D. II. Title.

TR183 .G75 2001
770′.1--dc21
 00-064845

Printed in China

6 7 8 9 10 - 11 10 09 08 07

CONTENTS

To Edith and Michel

&

To Patricia and David

ACKNOWLEDGMENTS

We thank Asa Baber, Jean Blomquist, Cynthia Clement, David Sherrill, and Julia Trott for editorial suggestions, Catherine Jacobes for design artistry, Publisher Philip Wood and Senior Editor Aaron Wehner of Ten Speed Press and our literary agent Sherrill Chidiac for their enthusiastic support, and Professor Duane Preble for his perceptive foreword.

FOREWORD

How has our collective consciousness been shaped by the media? Where do breakthrough insights come from? What provokes life's wonderful "aha's"? Why do we find the spontaneous convergence of certain forms, certain experiences, so aesthetically uplifting, so significant? Seeking spiritual nourishment in these roaring times of ferocious change, I ask such questions as I steer between the dislocations caused by too much fragmented information, proliferating technological complexities, the onslaught of commercial media, and the often static formulas of traditional religious guidance.

It is in this context that *The Tao of Photography* illuminates a path beyond the noise of constricted awareness, awakening in us the kind of intuitive awareness that raises life to a rewarding adventure and photography to an art. The springboard is unrestricted awareness taught by ancient Taoist philosophy and discovered in the reflective comments of leading photographers.

This book is a catalyst for reawakening the sense of wonder. It is a first-aid manual for those who yearn to be free of mind-numbing, predigested, media-generated views of reality. *The Tao of Photography* is about the harmonization of Little and Great Understanding. It is discovering the young child's and the sage's power to perceive awesome mystery in even the most ordinary objects and events. True art is an epiphany, an enlightening spark dancing in the perceived gap between ourselves and everything else.

Seeing is a creative process. *The Tao of Photography* mines the essence of that process and offers evidence in photographic form. The authors have opened a new, rewarding path to the heart of the creative attitude.

Meaningful art—in any medium—is mind changing, challenging the prejudices of conventional thought. In this role, art lives between the known and the unknown, communicating what it discovers in this ambiguous territory.

In *The Tao of Photography* we experience a great realization: the convergence across time and place of the resonant universal wisdom of Taoism and the wisdom of seeing within and beyond as revealed in the images and words of our era's photographers.

The mind-opening, spirited essence of this book is echoed elsewhere: Dizzy Gillespie, when asked where his jazz came from replied, "It's out there, man. Don't you hear it?" A teacher in India speaking about receiving grace said, "The winds of grace are blowing all the time. All you have to do is put up your sail." My favorite bumper sticker reads, "Don't believe everything you think."

On breaking through the enslavement of the judgmental mind, we wander freely, we welcome and embrace the unknown, the chaos, the mystery. We move beyond the prejudice of habitual understanding to spontaneous understanding. In this attitude of receptivity, we discover that we are open to the renewing energy of beauty in all that is.

May you awaken to the beauty of your own creative insights as you experience the heartfelt wisdom presented on the pages that follow.

—DUANE PREBLE
Professor Emeritus of Art

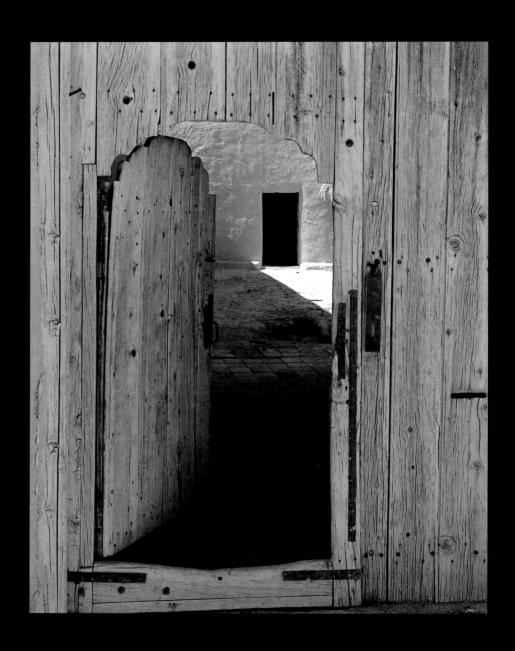

ELIOT PORTER
O'Keeffe's Entrance Door (outside)
Abiquiu, New Mexico, 1949

INTRODUCTION

Photography has been an integral part of my life since childhood.* A creative outlet at first, it evolved into a form of emotional healing and therapy, finally culminating in a way of life. Classical Asian psychologies of the mind, especially the Taoist philosophy of the *Chuang-tzu*, have also been an intensive pursuit of mine for years. These two passions developed independently, but one day I sensed that like the perfect Yin and perfect Yang, photography and Taoism could "mingle, penetrate, come together, harmonize," and that a blend of these disciplines could illuminate both the art of seeing and the art of living. It is this syncretism of the ancient wisdom of the *Chuang-tzu* and the art of creative photography that we will explore in *The Tao of Photography*. First, however, I will look back on my initiation into photography and how I came to associate photography with the wisdom of the *Chuang-tzu*.

Initiation Into Photography

When I was eight years old, my parents gave me a Kodak Instamatic camera. To my young, impressionable mind, it certainly lived up to one of its first marketing slogans: "You press the button and we do the rest." It was sheer magic: I was empowered by this gift. With this magic wand, just a little downward pressure of my finger allowed me to capture any subject or event. I was transformed into a powerful sorcerer. This sense of magic was at the core of my initial attraction to photography.

My new hobby was not always positive. Sometimes it brought out an inner tyrant. The images are still fixed in my memory: adults trying to please me with exaggerated smiles, others frantically trying to protect their faces by thrusting their hands in front of my lens. My infatuation with this newly found magic intensified at the photo lab when I retrieved the processed photographs. How marvelous to see my dog drooling on Grandma's new Sunday dress or the unflattering expressions of my friends devouring dessert.

Perfect Yin is stern and frigid;
Perfect Yang is bright and glittering.
The sternness and frigidity come forth from heaven, the brightness and glitter emerge from the earth; the two mingle, penetrate, come together, harmonize, and all things are born therefrom.

—*CHUANG-TZU*

* Personal anecdotes or the use of "I" relate to the first author, Philippe L. Gross.

TOP: Philippe L. Gross, *Street Musicians*
Lausanne, Switzerland, 1990

BOTTOM: Philippe L. Gross, *The Kiss*
Alsace, France, 1999

Once, in secondary school, after seven years of attempting to teach myself photography with my Instamatic, I borrowed a friend's reflex camera and enrolled in one of the only two photography classes I ever took. The class initiated me into the arcane mysteries of the darkroom. Seeing pictures materialize in the developer was so intoxicating, I immediately became a darkroom addict. I can still remember my teacher having to remove me physically from the darkroom at the end of the class because I wanted to make another "last" print. Developing my own prints magnified my magical powers, intensifying my commitment to photography even more. When I won first prize in the school photography contest, I finally bought my own reflex camera. I also installed a darkroom in my basement. A new phase of my camerawork now began.

IN THE DARKROOM

The convenience of having my own darkroom was an invaluable contribution to my study of photography. At first I mainly experimented with darkroom techniques and tried out different kinds of photographic equipment. Secretly I was hoping to create some instant masterpiece, but the rewards of my darkroom manipulations lay primarily in immediate visual excitement.

Because I had no real understanding of visual design, my approach to photography during this stage was quite chaotic. Eventually I became bored with my unstructured trials and temporarily abandoned darkroom experimentation. Instead I followed a previously successful formula, processing my black-and-white work mechanically and ignoring the individual needs of the prints. Inevitably this unexciting approach meant that I became less involved with darkroom work; I shifted my attention to making color slides.

Not until five years later did I again fall under the spell of the darkroom and black-and-white work, thanks to a growing understanding of visual design principles. My earlier experimentation in the darkroom (with such processes as framing, burning and dodging, contrast grade selection, and over- and underdevelopment) acquired new meaning. I began to appreciate the communicative power of photography and was able to create more successful pictures. My enthusiasm for darkroom work was reborn.

THE HASSELBLAD EXPERIENCE

Whenever I read about new photographers or looked at great pictures, I always wanted to know what equipment had been used. My obsession with equipment led me to purchase a second-hand Hasselblad 500 EL, similar to the model used on the

Apollo mission of 1969. I thought that this camera would give me the power to perform daily miracles. The delusion was painfully short-lived. My first shots were worse than the pictures I had made with the Kodak Instamatic. Only many rolls of film later did I discover that it was possible to produce pictures of high quality with my new camera. But first I had to realize that I was the one who had to do the work. I had to acknowledge that the legendary Hasselblad camera was substantially more difficult to use than a conventional 35mm reflex camera with a built-in metering system. If I wanted to succeed with this camera, I would have to relinquish my entrenched perspective and adjust my vision to the perspective built into the camera. I would have to abandon past securities and adapt myself to the camera's peculiar exigencies.

The "Hassy" 500 EL was a heavy, cumbersome, medium-format camera with a noisy, built-in motor drive. Its square image on the focusing screen was inverted, and because the camera had a top viewfinder, it had to be held level with my belly rather than in front of my eyes. For me, the worst drawback to this behemoth was its lack of a built-in light meter. The Hasselblad is one of the best cameras ever made. But, alas, I didn't have enough money to buy the accessories that would have transformed my camera into a more flexible and useful piece of equipment. I had to make do with its most basic features. And this large, conspicuous camera was probably one of the worst possible choices for one of my favorite photographic activities—candid street shots. Ironically, each inconvenience became a valuable opportunity to develop essential photographic skills.

To begin with, the Hasselblad's inverted viewfinder taught me a new way of seeing. I was able to avoid a common error that many beginners make when they evaluate a scene in terms of the human eye and then try to capture it with the camera. My usual cues were unavailable because the image was inverted, and I was obliged to compose a subject within the viewfinder by directly thinking of it as it would look as a final print. Having to look through a viewfinder at belly height gave me a fresh perspective from which I could explore my subjects from unconventional angles. Also, the square format of the viewfinder emancipated my compositions from the familiar rectangular shape of most published photographs.

The daunting absence of a light meter was to become another boon. I was forced to become more aware of the intensity of the light on my subjects and had to learn

TOP: Philippe L. Gross, *Lead Dog*
Venice Beach, California, 1999

BOTTOM: Philippe L. Gross, *Bench*
Paris, 1999

3

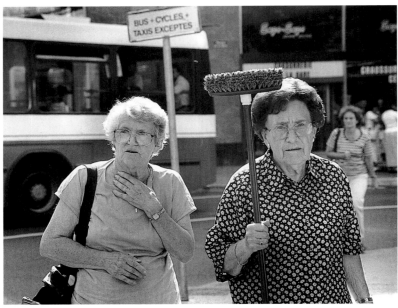

Philippe L. Gross, *Two Women*
Fribourg, Switzerland, 1997

to translate this intensity into a workable exposure value (EV). This increased my appreciation of shadows and other contrasting elements. It also provoked me to experiment with bracketing—photographing the same subject at variable diaphragm settings or shutter speeds in order to create the most suitable picture. In turn, the prints resulting from bracketing taught me how the emotional content of a picture can vary with the slightest variations in the exposure value. Later on, the hand-held light meter I acquired further increased my sensitivity to even the most minute gradations of light.

The built-in motor drive of my camera was so noisy that I could take only one candid shot before being heard and discovered. This constraint made it necessary to be sure of subject, composition, and camera settings beforehand to capture the image I intended on the first shot.

In the final analysis, the Hasselblad taught me to think in photographic terms and to develop necessary technical skills. Perhaps with a less prestigious camera I could have blamed my initial poor results on the equipment, but the famous Hasselblad name on the camera challenged me to live up to its standards and to persist through a long trial-and-error apprenticeship. At long last I matured enough to realize that equipment alone cannot insure photographic artistry. It was time to bid farewell to my magic wand theory.

Photography and Liberation

Our personal growth can fuel our photography and our photography can fuel our personal growth.

—Brooks Jensen

As I became more experienced, the technical aspects of photography, still important, became less of a preoccupation. Once again I was drawn into the experiential aspects of photography. I began to feel that my practice of photography was more than just to create beautiful pictures—it was a way to connect more deeply with the world. Something would come over me that was difficult to express in words at the time.

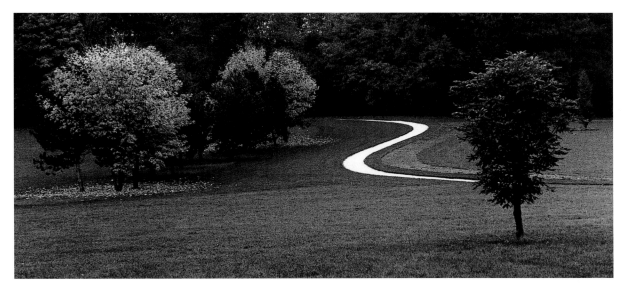

Philippe L. Gross, *Z Path*
Geneva, 1987

An unhappy teenager, I had instinctively turned to photography for solace from broodings about the meaning of life. And photography was not a required course of study like most of my other activities. Small wonder then that photography became my chief creative outlet and a source of healing. My preoccupation with the insistent existential questions of youth was suspended when shooting pictures or developing them in the darkroom. In these precious, joyful moments I felt totally "in the present." No questions arose, no answers were required.

When unpleasant thoughts persistently clouded my mind or disturbing emotions drained away my vital strength, I felt compelled sometimes to grab my camera and roam the streets or wander about in some natural setting. Invariably my unpleasant mood would soon yield to a lightheartedness and a sense of being grounded. It was as though the constriction of being trapped in an enclosed, fragile self had been transcended by a sudden opening into the surrounding world.

Although my remedy for chasing away disagreeable thoughts and emotions might be misconstrued as escapism, I view it in a positive light—a valuable therapeutic practice for personal growth. Now it's clear to me that photography provides an exceptional opportunity to experience being fully alive in the present and attuned to my surroundings. Simply having a camera around my neck enhances my awareness of the moment.

I owe this deeper appreciation of photography to studying the *Chuang-tzu*, a text two thousand years older than the invention of photography.

The *Chuang-tzu* and the Art of Photography

The *Chuang-tzu* is an ancient Taoist collection of writings most likely compiled in the fourth, third, and second centuries B.C.E. Lao-tzu's *Tao Te Ching* and the *Chuang-tzu* are recognized as the most important works of philosophical Taoism. It is said of Chuang Chou, a reputed author of the *Chuang-tzu*:

> Above he wandered with the Creator, below he made friends with
> those who have gotten outside of life and death, who know nothing
> of beginning or end. As for the Source, his grasp of it was broad,
> expansive, and penetrating; profound, liberal, and unimpeded....
> In responding to change and expounding on the world of things, he
> set forth principles that will never cease to be valid, an approach
> that can never be shuffled off.

Although uncertainties remain about the precise authorship of this distinctive work, it has long been recognized for its vivid and imaginative style in characterizing Taoist principles as they are manifest in the everyday life of the Taoist sage.

The *Chuang-tzu* is an engaging, earthy, literary work—by turns didactic, anecdotal, and comical. It is a guide to Taoist wisdom, the obstacles to self-understanding, and the characteristics of the sage—one who has leaped into the boundless and made it home.

We have used the *Chuang-tzu* as a classroom text for some years and personally as a guide to the art of living. In addition to our interest in the *Chuang-tzu*, we also share an interest in the practice of photography. We could not help but notice that the characteristics of the sage found in the *Chuang-tzu* are sometimes echoed by statements we find in the photography literature about the art of creative photography.

Can a work written more than two thousand years ago be a guide to photographic artistry? Our answer is a resounding "yes"! This book shows why.

For the camera, the creative moment is brief— a compelling, ephemeral collision of event and artist. Extreme awareness combined with unobtrusiveness becomes the context the photographer must work within.

—KEN RUTH

PART I

PRINCIPLES OF TAOISTIC PHOTOGRAPHY

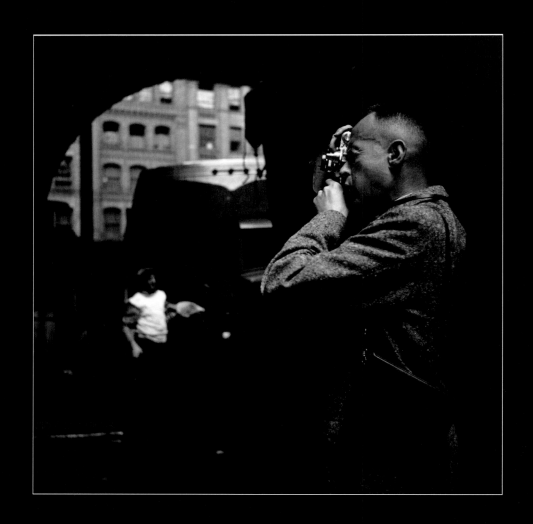

GENEVIEVE NAYLOR
Photographer Under the Brooklyn Bridge
Henri Cartier-Bresson photographs the streets of Brooklyn

PRINCIPLES OF TAOISTIC PHOTOGRAPHY

The Taoist sage, free from the entanglement of the discriminatory mind, harmonizes Little Understanding and Great Understanding, thus effortlessly living out a peaceful life. Liberated life, as portrayed in the *Chuang-tzu,* reveals a variety of psychological characteristics that can be related to photographic practice.

Although few creative photographers are likely to have direct knowledge of the *Chuang-tzu,* the principles they sometimes advocate to liberate one's vision and increase photographic artistry bear a remarkable resemblance to the principles of sagehood expressed in this ancient text.

Constricted and Unconstricted Awareness

Great understanding is broad and unhurried;
little understanding is cramped and busy.

—*Chuang-tzu*

The *Chuang-tzu* depicts ordinary life as unliberated and hurried, even frantic, consumed by perpetual busyness or slavish habits. In the following parable, the text illustrates the sad, relentless pace of the unliberated life:

> Once there was a man who was afraid of his shadow and who hated
> his footprints, and so he tried to get away from them by running. But
> the more he lifted his feet and put them down again, the more
> footprints he made. And no matter how fast he ran, his shadow never
> left him, and so, thinking that he was still going too slowly, he ran
> faster and faster without a stop until his strength gave out and he fell
> down dead. He didn't understand that by lolling in the shade he could
> have gotten rid of his shadow and by resting in quietude he could
> have put an end to his footprints. How could he have been so stupid!

Leap into the boundless and
make it your home!

—*Chuang-tzu*

9

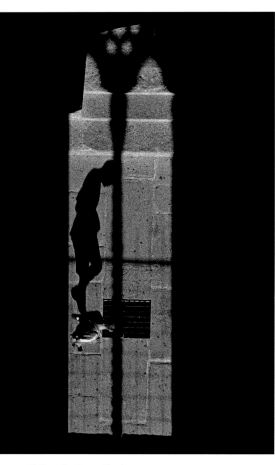

Philippe L. Gross, *Shadow*
Florence, Italy, 1999

The flight from conscious existence is provoked by stubborn beliefs and unyielding goals. Awareness is so constricted that the possibility of change is not even recognized.

In photography, the unliberated photographer is usually described as a mindless imitator. Such imitators can be observed daily at tourist sites all over the world:

> Arriving at the rim of this famous landmark, they shuffle about,
> searching for a sign that says "shoot here." With one pre-set image
> labeled GRAND CANYON in their minds, blinding them to what
> lies below, they search for the one and only "right" spot to stand.
> —JOEL MEYEROWITZ

Constricted by preset images, such photographers mechanically attempt to reproduce a rigid, preestablished vision, thereby forestalling the possibility of new discoveries. Their awareness is saturated with expectations that block the possibility of seeing the unexpected.

We regard the unliberated life in the *Chuang-tzu* and the unliberated practice of photography as representative of the state of *constricted awareness*. The awareness of the man afraid of his own shadow is constricted by an unquestioned belief about its threatening nature. The unliberated photographer's awareness is constricted by expectations about "how things ought to look." But what is the source of these constricted, unliberated approaches to life and art?

The *Chuang-tzu* maintains that the root of the unliberated life is the *discriminatory mind*, a frame of mind that creates endless discriminations where none existed before. The perceiver discriminates between the self and the various elements that constitute the ongoing process of nature. Maintaining this sense of separation, the perceiver constantly evaluates phenomena by means of subjective judgments of approval and disapproval. The continual act of discrimination induces a sense of separateness between the subject and the object.

By constantly making such judgments, the perceiver soon becomes subservient to the discriminatory mind—that is, a judgmental frame of mind constantly rejecting what is disliked and attempting to possess or prolong what is liked. However, since both what is liked and what is disliked are inseparable elements of the whole fabric of nature, to favor one element and reject another creates disharmony where none existed before. Partiality creates disharmony.

In the practice of photography, constricted awareness can impoverish a photographer's vision and art. Imprisoned by biases of the discriminatory mind, the

photographer with constricted awareness is unable to appreciate the boundless visual richness of the world that lies beyond the filters and projections imposed by mental constructs. Only when the photographer can become free of the discriminatory mind can creative, unconstricted seeing occur.

Let us examine more closely the source of constricted awareness according to the *Chuang-tzu*, for this ancient work claims that freedom from the unliberated life is readily at hand, and that one can escape the relentless pursuit of one's shadow simply by "lolling in the shade" and "resting in quietude." How is this possible?

The *Chuang-tzu* differentiates between two types of understanding, the Great and the Little: "Great understanding is broad and unhurried; little understanding is cramped and busy." Although the ability to discriminate is beneficial for survival purposes, it can easily become an autonomous mental reflex for responding to all situations. When this happens, Great Understanding is lost: openness, receptivity, and holistic perception and understanding are repressed. We might suppose, therefore, that to counter Little Understanding we should run after Great Understanding. But the *Chuang-tzu*'s counsel is not simply to cast away Little Understanding: the sage is one who *harmonizes* Great Understanding and Little Understanding:

> In being one, he [the sage or the True Man] was acting as a companion of Heaven. In not being one, he was acting as a companion of man. When man and Heaven do not defeat each other, then we may be said to have the True Man.

A parallel to the two types of understanding described in the *Chuang-tzu* can also be found in the photography literature. Generally speaking, Little Understanding in camerawork represents the frame of mind that concentrates on techniques, sets goals, applies photographic rules, arranges a scene to fit a desired outcome, and attempts to gain total control over the subject. Great Understanding, on the other hand, corresponds to the photographer's ability to respond holistically and spontaneously to a scene without overtly interfering with the subject. Ultimately, the liberated photographer, like the sage in the *Chuang-tzu*, is a companion of both forms of understanding: to develop one's artistic ability demands first fully knowing and

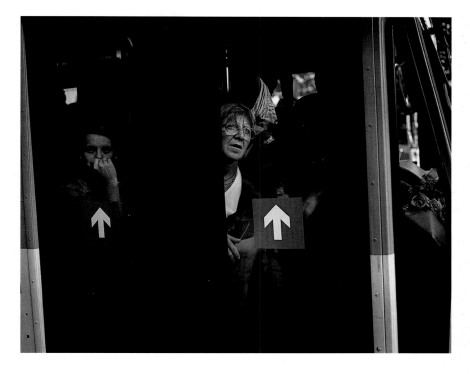

Philippe L. Gross, *On the Bus*
Paris, 1999

Seeing, in the finest and broadest sense, means using your senses, your intellect, and your emotions. It means encountering your subject matter with your whole being. It means looking beyond the labels of things and discovering the remarkable world around you.

—FREEMAN PATTERSON

then transcending techniques—seeing, feeling, and responding holistically to a photographic scene. In this last stage, photographic skills initially acquired are now integrated into the photographer's ability to respond spontaneously to a situation.

So mastery of a technical skill does not mean rejecting Little Understanding. It simply means freedom from the belief that the discriminatory mind is a reliable, necessary, or exclusive guide to artistry and living. The creative artist can make use of Little Understanding without being entangled by it. Great Understanding exerts itself unencumbered: the shadows recede, leaving artistry free to reveal itself.

As well as illuminating the nature of Great Understanding and Little Understanding, the *Chuang-tzu* describes specific characteristics of sagehood. Although it does not directly enumerate a list of the main characteristics of the sage, we found it useful to compile such a list from the many descriptions of sagehood scattered throughout the work. They can be classified according to the following related concepts: (a) freedom from the sense of self; (b) receptivity; (c) *wu-wei* (nonforceful action); (d) spontaneity; (e) nonattachment; (f) acceptance; (g) resourcefulness; (h) *te* (virtue/power); and (i) free and easy wandering.

Freedom From the Sense of Self

> *Forget things, forget Heaven, and be called a forgetter of self. The man who has forgotten self may be said to have entered Heaven.*
>
> *—Chuang-tzu*

The *Chuang-tzu* invites the reader to challenge the ordinarily unquestioned assumption about a fixed, ongoing personal self. The following passage, for example, insinuates that because what we call "I" manifests itself under different forms, we may not know what this "I" really refers to—or even that it actually exists:

> What's more, we go around telling each other, I do this, I do that—
> but how do we know that this "I" we talk about has any "I" to it?
> You dream you're a bird and soar up into the sky; you dream you're
> a fish and dive down in the pool. But now when you tell me about it,
> I don't know whether you are awake or whether you are dreaming.

A similar challenge to the conventional sense of self is found in the next quotation, in which the self is perceived not as a stable, autonomous entity but as dependent on one's subjective point of view:

Once Chuang Chou dreamt he was a butterfly, a butterfly flitting and fluttering around, happy with himself and doing as he pleased. He didn't know he was Chuang Chou. Suddenly he woke up and there he was, solid and unmistakable Chuang Chou. But he didn't know if he was Chuang Chou who had dreamt he was a butterfly, or a butterfly dreaming he was Chuang Chou. Between Chuang Chou and a butterfly there must be some distinction! This is called the Transformation of Things.

For Chuang Chou, to identify at one instant with Chuang Chou and at another with a butterfly does not mean that Chuang Chou and the butterfly are separate entities. Note that the passage does not state that "he didn't know if he was Chuang Chou or if he was a butterfly," but that "he didn't know if he was Chuang Chou *who had dreamt he was a butterfly*, or a butterfly *dreaming he was Chuang Chou*" [emphasis added]. This suggests that Chuang Chou and the butterfly are not to be perceived as separate and autonomous manifestations but as alternative perspectives: together with all else in the universe, they are a part of an eternal flux, the "Transformation of Things."

When one recognizes the indivisibility of human beings and the environment, it makes little sense to proclaim: "This is me! And there is the environment." By not limiting awareness to a unique sense of self, the Taoist sage is able to embrace fully—indeed, be an integral part of—the whole process of nature happening. The sense of self is forgotten, lost in a greater universal perspective—the Tao.

Some photographers hint at this experience of being free from the sense of self. For example, Jeff Berner, in *The Photographic Experience*, describes conscious camerawork as an unobstructed communion between self and environment: "After probing appearances and deepening vision through the 'second sight' of photography, the photographer emerges as one in whom experience is a perpetual communion, with or without the lens."

The merging of self and environment in the practice of photography may lead to the recognition that it is no longer the individuated self who takes the picture but that the picture is being taken by itself. "There comes a moment," writes Sebastião Salgado, "when it is no longer you who takes the photograph, but receives the way to do it quite naturally and fully."

For some photographers, the merging of self with the photographic subject matter is a prerequisite if one's vision is to be effectively expressed in the language of photography. Adam Jahiel says, "If we do our job right, we in a sense become what

14

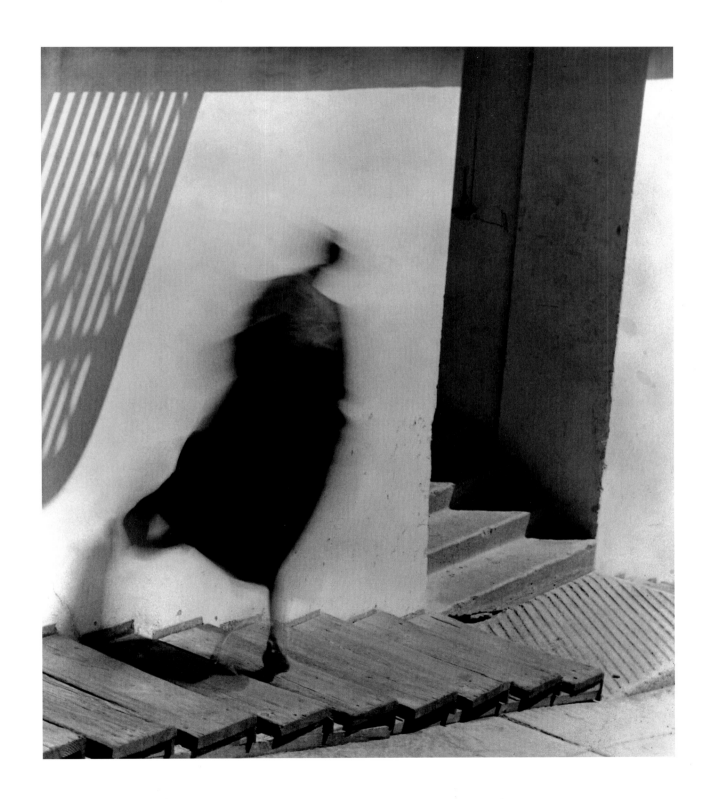

15

MY PICTURES ARE NEVER PRE-VISUALIZED OR PLANNED. I FEEL STRONGLY THAT PICTURES MUST COME FROM CONTACT WITH THINGS AT THE TIME AND PLACE OF TAKING. AT SUCH TIMES, I RELY ON INTUITIVE, PERCEPTUAL RESPONSES TO GUIDE ME, USING REASON ONLY AFTER THE FINAL PRINT IS MADE TO ACCEPT OR REJECT THE RESULTS OF MY WORK.

—WYNN BULLOCK

WYNN BULLOCK
Stark Tree, 1956

Philippe L. Gross, *Epiphany*
Fribourg, Switzerland, 1999

we photograph." Henri Cartier-Bresson, emphasizing the need to forget oneself, also suggests that a photographer must merge with the environment: "I find that you have to blend in like a fish in water, you have to forget yourself." Cartier-Bresson elaborates more directly on the necessity of being free from the sense of self:

> I'm not responsible for my photographs. Photography is not
> documentary, but intuition, a poetic experience. It's drowning
> yourself, dissolving yourself and then sniff, sniff, sniff—being sensitive
> to coincidence. You can't go looking for it; you can't want it, or you
> won't get it. First you must lose your self. Then it happens.

Receptivity

The sage's mind in stillness is the mirror of Heaven and earth, the glass of the ten thousand things.

—Chuang-tzu

Freedom from the sense of a fixed self and receptivity are closely related. The capacity to be fully receptive is obstructed if the sense of self stands in the way of a holistic perception of the world. The *Chuang-tzu* notes that the constant influx of socially reinforced values, such as the desire for fame, wealth, and knowledge, helps keep alive the illusion of an abiding self: "With likes and dislikes, sounds and colors, you cripple what is on the inside; with leather caps and snipefeathered bonnets, batons stuck in belts and sashes trailing, you cramp what is on the outside." According to the *Chuang-tzu*, when one is free from the frame of mind of Little Understanding—that is, when one is no longer subservient to various discriminations stemming from the wish for recognition and authority, or to the habit of rejecting and accepting, liking and disliking—then the frame of mind of Great Understanding manifests itself. Great Understanding is a state of mind empty of received ideas and beliefs. It is not a blank, nihilistic state in which nothing exists, but one of openness and receptivity, a state wherein past knowledge neither taints nor constricts the perception of the present moment in all its fullness. Such a state of receptivity is also alluded to by some creative photographers:

> It's easy to fall into imitating yourself. I try to take a fresh
> approach to all the shots, to be really open to what I'm seeing
> rather than having a premeditated idea about what I'm going to

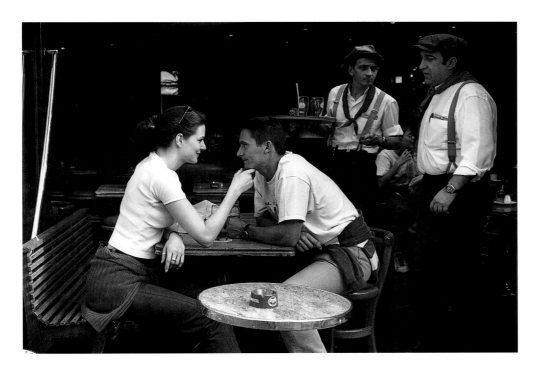

Philippe L. Gross, *Café*
Paris, 1999

shoot, or forcing a statement out of something that's not there. My
good pictures really come from my being responsive.

—ALEX MACLEAN

Out in the field I try not to hold expectations. I try to achieve an
openness. The senses heighten so that I'm totally immersed in what's
happening at the moment. I want to be receptive to an image
coming together.

—KEITH LAZELLE

Some photographers also regard a receptive attitude as the most effective way
to avoid photographic clichés. In an interview about his practice of photography,
Edouart Boubat says:

All my photographs are about meetings and about *coups de foudre*—
love at first sight. To do that type of photography, one must wipe
the canvas clean to prepare for chance encounters, be open and
aware to such moments, otherwise it becomes a cliché—already seen
and expected.

By being open to both the environment and his own emotions, experiencing *coups de foudre*, Boubat prevents his sense of self from interfering with his chance encounters; rather it merges with them, allowing him to respond instantaneously to photographic opportunities. Such an ability to be open, according to Kathryn Marx, promotes receptivity: "The greater the range of emotions that you permit yourself to feel and show, the greater is your receptivity to what you see before your viewfinder."

In practice, however, receptivity is not always a conspicuous element in photography; indeed the impulse to take total control of the creative process often predominates. Nevertheless, most photographers, even the most controlling ones, recognize that receptivity plays a vital role in their work simply because they must frequently act instantly. In general, both control and receptivity can contribute to the practice of photography:

> A split-second decision determines whether you capture a situation,
> as well as how well you capture it. You've already thought about
> your subject and know the reason why you've placed yourself in a
> particular situation. But once you are there, you must try to empty
> your mind of all thought in order for you to be completely in the
> moment and receptive to your intuition and your surroundings.
> Simply react to them with uncluttered clarity.
>
> —KATHRYN MARX

In sum, receptivity in the *Chuang-tzu* corresponds to an open state of mind in which the present moment is experienced in its full richness, free from the entanglement of the discriminatory mind. In photography, receptivity is described as freedom from premeditated ideas, openness to seeing the world freshly, renouncing expectations, being immersed in the photographic moment, and sensitivity to one's emotions. In both the *Chuang-tzu* and in photography, receptivity implies release from the bonds of past knowledge, opening a gateway to full immersion in the immediate moment.

Beyond its usefulness for creating good photographs, receptivity is also a state of mind worthy of enjoyment in and of itself. When asked what he looks for in photographing, Michael Smith replied: "I am not looking for anything. I'm just looking—trying to have as full an experience as possible. The point is to have a full experience—the photograph is just a bonus."

Smith's comment hints at another Taoist concept—that when attuned to the Tao, an individual can be effortlessly creative and productive. The Chinese expression for this concept is *wu-wei,* and it is another of the characteristics of the sage in the *Chuang-tzu.*

Wu-wei

> *Superiors must adopt inaction and make the world work for them;*
> *inferiors must adopt action and work for the world.*
>
> *—Chuang-tzu*

Wu-wei has been variously translated by scholars into English as "inaction," "not forcing," and "doing nothing." Comparative philosopher Roger Ames describes the concept of *wu-wei* as "responding with an awareness that enables one to maximize the creative possibilities of himself in his environment." To Burton Watson—well known for his translation of the *Chuang-tzu*—*wu-wei* means that the sage does not ratiocinate before acting but adopts "a course of action that is not founded upon any purposeful motives of gain or striving." This seems to correspond to the photographer Brett Weston's observation: "When I photograph, I don't have anything in mind except the photograph. I don't think in terms of magazines, books, or promotions. I photograph for the love and the excitement."

Alan Watts interprets the dynamics of *wu-wei* in the following way:

> *Wu-wei* is thus the life-style of one who follows the Tao, and must be
> understood primarily as a form of intelligence—that is, of knowing
> the principles, structures, and trends of human and natural affairs so
> well that one uses the least amount of energy in dealing with them.

The following passage by Brett's father, Edward Weston, illustrates the dynamics of *wu-wei* in photography:

> One does not think during creative work, any more than one thinks
> when driving a car. But one has a background of years—learning,
> unlearning; success, failure, dreaming, thinking, experience, all this—
> then the moment of creation, the focusing of all into the moment. So
> I can make "without thought," fifteen carefully considered negatives,
> one every fifteen minutes, given material with as many possibilities.
> But there is all the eyes have seen in this life to influence me.

Another approach to understanding *wu-wei* is to consider the difference between the way a lioness and a spider catch their respective prey. The lioness runs purposefully after the gazelle, often exhausting herself; the spider aimlessly builds her net, serenely waiting for the fly to come. We can see this spiderlike attitude reflected in the teaching of a Japanese archery master:

> There are processes which are beyond the reach of understanding. Do not forget that even in Nature there are correspondences which cannot be understood, and yet are so real that we have grown accustomed to them, just as if they could not be any different. I will give you an example which I have often puzzled over. The spider dances her web without knowing that there are flies who will get caught in it. The fly, dancing nonchalantly on a sunbeam, gets caught in the net without knowing what lies in store. But through both of them "It" dances, and inside and outside are united in this dance. So, too, the archer hits the target without having aimed—more I cannot say.
>
> —EUGEN HERRIGEL

The concept of effortless effort can also be found in the photography literature:

> I never look for a photograph. The photograph finds me and says, "I'm here!" and I say, "Yes I see you. I hear you."
>
> —RUTH BERNHARD

> Throughout my life I've never pursued anything. I just let things pursue me...they just show up.... This is the way I've led my life, not just in photography, but in life.
>
> —MANUEL ALVAREZ BRAVO

Wu-wei should certainly not be construed as indolence; on the contrary, it is a very effective, fluent way to get things done. To act in accord with the principle of *wu-wei*, one must remain in a state of receptivity—not passive or torpid, but relaxed and alert, continuously attuned to the ceaseless transformations of life. This state of inward and outward harmonization with the flow of life allows both the sage and the creative photographer to act naturally and spontaneously.

The effectiveness of *wu-wei* can be seen to derive from two principles of energy management. The first principle is that the forces of nature, as a whole, are stronger and more effective than the forces deployed by an individual alone. When

one understands the way of nature and can merge with its forces, one can effortlessly achieve striking results. In the words of the *Chuang-tzu*: "To spend little effort and achieve big results—that is the Way of the sage."

The second principle is that a constricted mind, entangled in endless discriminations, cannot perform as well as a receptive, unconstricted mind. The *Chuang-tzu* illustrates how the spontaneity of skillful actions is blocked when Little Understanding interferes with rather than harmonizes with Great Understanding:

> When you're betting for tiles in an archery contest, you shoot with
> skill. When you're betting for fancy belt buckles, you worry about your
> aim. And when you're betting for real gold, you're a nervous wreck.
> Your skill is the same in all three cases—but because one prize means
> more to you than another, you let outside considerations weigh on your
> mind. He who looks too hard at the outside gets clumsy on the inside.

Paradoxically, the purposeless characteristic of *wu-wei* is purposeful; its purpose is not to let purpose get in the way of the goal to be attained. An exchange between Zen practitioner Eugen Herrigel and his archery master illustrates how a goal can be reached by giving up the attempt to reach it:

> "The right art," cried the Master, "is purposeless, aimless! The more
> obstinately you try to learn how to shoot the arrow for the sake of
> hitting the goal, the less you will succeed.... What stands in your
> way is that you have a much too willful will. You think that what
> you do not do yourself does not happen." ... "What must I do,
> then?" I asked thoughtfully. "You must learn to wait properly."
> "And how does one learn that?" "By letting go of yourself, leaving
> yourself and everything yours behind you so decisively that nothing
> more is left of you but a purposeless tension."

This exchange—in addition to being a reminder of the intrinsic relationship among receptivity, *wu-wei*, and freedom from the sense of self—reveals how receptivity is not a passive state of mind like napping or dozing. It is a condition of relaxed alertness in which an individual remains continuously attuned to the everchanging process of life—inwardly and outwardly. The sage, therefore, has no need to weigh laboriously the pros and cons of every potential action and then decide which course to follow. The Way is already contained within the flow of life. Being attuned to it, the sage simply acts in concert with the flowing nature of life.

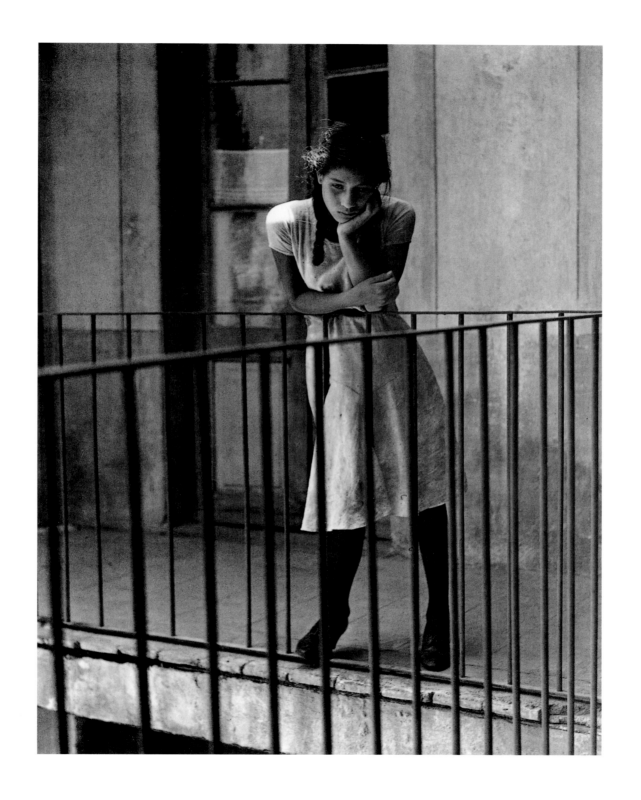

25

IN PHOTOGRAPHY, THE SMALLEST THING CAN BE
A GREAT SUBJECT. THE LITTLE, HUMAN DETAIL CAN
BECOME A LEITMOTIV.

—HENRI CARTIER-BRESSON

HENRI CARTIER-BRESSON
Ile de Sifnos, Cyclades, Greece

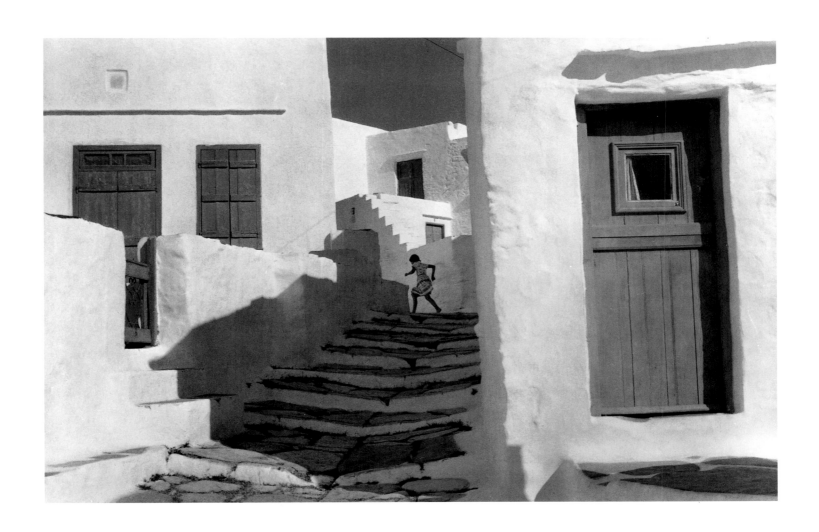

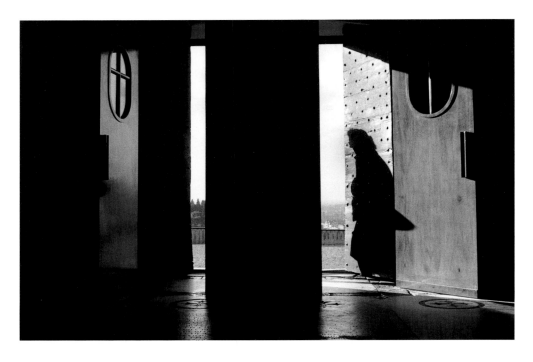

Spontaneity

*[The sage] constantly goes by the spontaneous, and does not add
anything to the process of life.*

—Chuang-tzu

Most photographers recognize spontaneity as an essential component of their art. A posed photograph rarely has as much of an impact upon an audience as a spontaneous one. Ellen Denuto says: "Even when working on assignment, my best images are those that are spontaneous. I find my best work is unplanned—it comes from the heart. I photograph what moves me." Spontaneity, as the late sinologist Angus Graham explains, is also one of the basic tenets of Taoist philosophy:

> While all other things move spontaneously on the course proper to them, man has stunted and maimed his spontaneous aptitude by the habit of distinguishing alternatives, the right and the wrong, benefit and harm, self and others, and reasoning in order to judge between them. To recover and educate his knack he must learn to reflect his situation with the unclouded clarity of a mirror, and respond to it with the immediacy of an echo to a sound or shadow to a shape.

This description of spontaneity is echoed in the writings of one of the masters of spontaneous photography, Henri Cartier-Bresson: "For me, the camera is a sketchbook, an instrument of intuition and spontaneity, the master of the instant which, in visual terms, questions and decides simultaneously."

Graham and Cartier-Bresson concur in suggesting that spontaneous actions involve a synchronicity between subject and object. In Graham's words, subject and object respond to each other "with the immediacy of an echo to a sound or shadow to a shape." Cartier-Bresson explains this idea in terms of the simultaneity of questioning and deciding. Both writers also imply that spontaneity requires an involvement between subject and object. For Cartier-Bresson, the photographer needs to "feel involved in what one singles out through the viewfinder." Graham, in his exposition of the *Chuang-tzu*, uses stronger terms, stating that the subject is totally absorbed in the object:

> People who really know what they are doing, such as a cook carving
> an ox, or a carpenter or an angler, do not precede each move by
> weighing the arguments for different alternatives. They spread atten-
> tion over the whole situation, let its focus roam freely, forget
> themselves in their total absorption in the object, and then the
> trained hand reacts spontaneously with a confidence and precision
> impossible to anyone who is applying rules and thinking out moves.

Spontaneity in the *Chuang-tzu*, according to Graham, naturally occurs when a person forgets the self and gives up the compulsion to control the environment. Only when one is fully in tune with the ever-changing environment can one harmoniously respond to it like the "echo to a sound or shadow to a shape."

Nonattachment

The Perfect Man uses his mind like a mirror—going after nothing,
welcoming nothing, responding but not storing.

—Chuang-tzu

In harmony with the parade of life's ceaseless transformations, the sage is not attached to particular events or to a particular way of life. By remaining nonattached, the sage does not engender conflict with the environment, choosing instead to embrace everything as one seamless field of nature. Such a state of nonattachment,

THE BEST WAY TO GO INTO AN UNKNOWN

TERRITORY IS TO GO IN IGNORANT....

—DOROTHEA LANGE

DOROTHEA LANGE
Man Stepping off a Cable Car, 1956

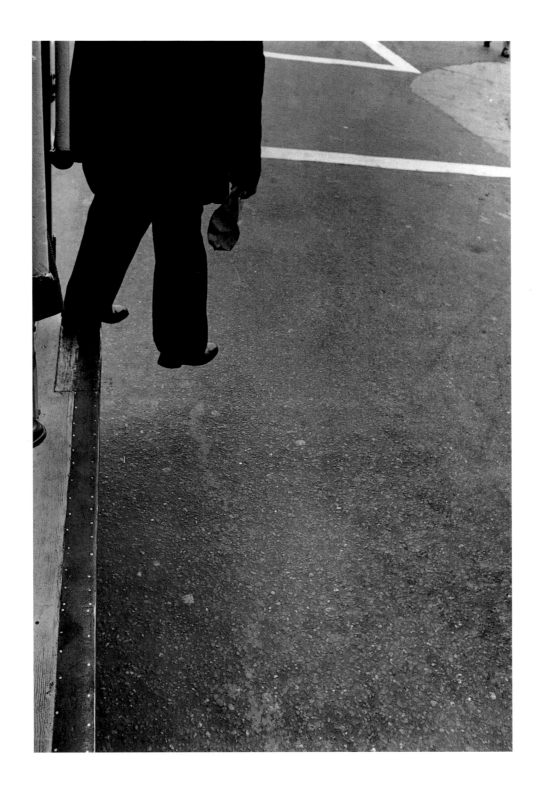

as Herrigel explains, is also the ideal condition for the practicing artist: "Out of the fullness of this presence of mind, disturbed by no ulterior motive, the artist who is released from all attachment must practice his art."

In photography, being nonattached—especially to conventional perception—plays an important role in the photographer's ability to be aware of the constant flux of life and therefore responsive to new or changing scenes. In *The Art of Seeing*, Derek Doeffinger advises photographers to release their expectations so that they can be free to resonate with the environment they photograph:

> Don't try to subdue a subject to your way of thinking—you can't push a piano through a porthole. Go with the flow. Be flexible. Adapt. The scene will not adapt to you, as you'll discover when viewing your pictures.... Don't let your expectations project mirages that leave you thirsting. Release expectations. Defy assumptions. Unite with the scene to see not what you want to see, but what's there. Then strengthen the strong points to build the photograph you want. Sometimes a situation will prove to be unphotogenic. Recognize when that happens and be on your merry way looking for something else.

As Doeffinger suggests, not only can the attachment to preset images sometimes produce frustration, it can also interfere with creativity by constraining the photographer from freely adapting to the environment at hand.

Attachment to habitual ways of seeing can thus impede clear seeing by interposing filters of expectations (e.g., visual expectations) between the environment and the viewer. Conversely, by not being attached to predefined images, the liberated photographer, like the Taoist sage, can respond creatively and freshly to life's changing circumstances.

Impermanence, transition, and transformation can all be blessings for the percipient photographer. Indeed, if things never changed, photography would quickly become a boring occupation—the photographer would soon become jaded and starved for surprises. Constant change, from this perspective, ensures that the universe will continue to provide new images.

In a world that is by nature always in flux, wave after wave of photographic opportunities keeps rolling in. The photographer who is aware of this boundless stream, also realizes that attachment to a lost image (e.g., lamenting a missed shot)

is not only unproductive but also constricts awareness and interferes with the perception of new photographic possibilities.

Apprehending the law of ceaseless transformation, the unconstricted photographer can remain in a state of relaxed alertness, open to oncoming waves of opportunity. The French surrealist André Breton once described Cartier-Bresson's attitude in these terms:

> Actually it's quite true that he's not waiting for anyone since he's not made any appointment, but the very fact that he's adopting this ultra-receptive posture means that by this he wants to help chance along, how should I say, to put himself in a state of grace with chance, so that something might happen, so that someone might drop in.

Acceptance

> *Mysteriously, wonderfully, I bid farewell to what goes, I greet what comes; for what comes cannot be denied, and what goes cannot be detained.*
>
> —*Chuang-tzu*

Acceptance in the *Chuang-tzu* is not a form of resignation but a natural response when one is in tune with the manifestations of nature. By embracing all of life, the sage can remain free of inner as well as outer conflicts.

Acceptance is also a characteristic of the unconstricted, Taoistic photographer—that is, one not unduly governed by preestablished thought, perception, interpretation, and action. Acceptance, especially with regard to subject matter and atmospheric conditions, allows the photographer to explore photographic visions beyond the bounds of the conventional.

Both the sage and the Taoistic photographer, having unconstricted awareness, are capable of seeing the miraculous in the ordinary. Such vision, however, requires a nondiscriminatory, accepting attitude toward all aspects of life. In contrast, when photographers insist upon capturing only smiling faces or sunny landscapes, they cast away the miraculousness of other moments and fail to appreciate life's fullness.

Analyzing Diane Arbus's photographs, the critic Susan Sontag explains that Arbus's unusual images offer "an occasion to demonstrate that life's horror can be

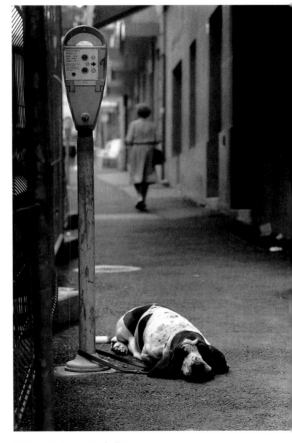

Philippe L. Gross, *Parked Dog*
Fribourg, Switzerland, 1994

33

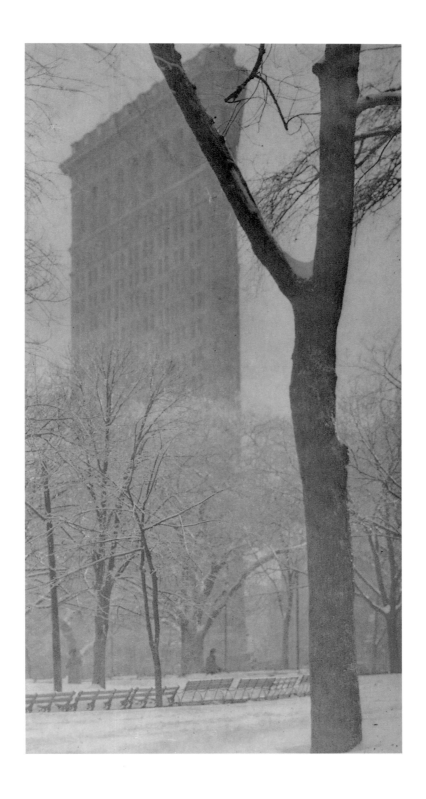

GEORGE A. TICE
Petit's Mobil Station
Cherry Hill, New Jersey, 1974

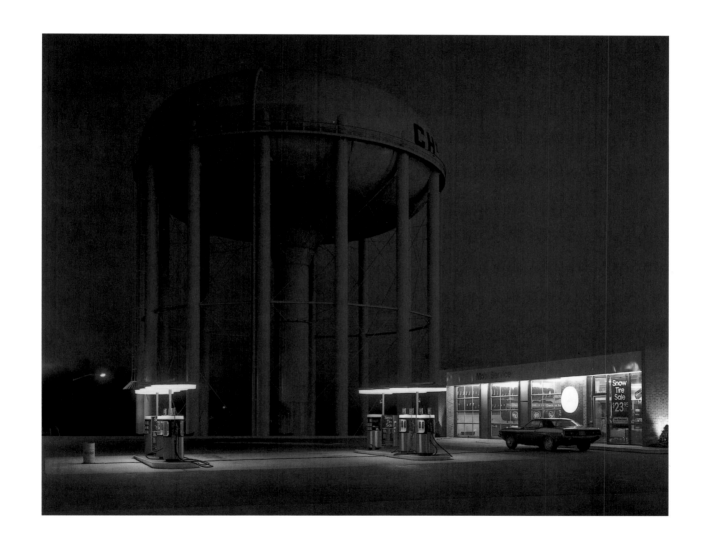

37

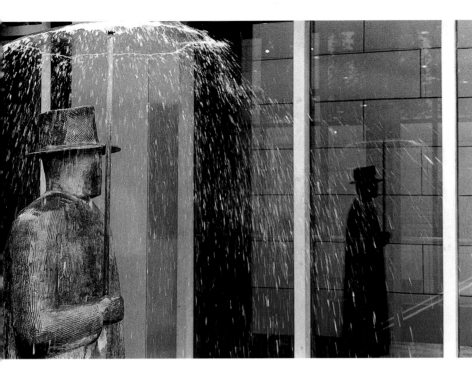

Philippe L. Gross, *Rain Man*
Lausanne, Switzerland, 1999

faced without squeamishness. The photographer once had to say to herself, Okay, I can accept that; the viewer is invited to make the same declaration." Arbus's ability to accept what was deemed unacceptable in her time expanded the definition of what is now considered appropriate to photograph, as well as enriching her own life: "Freaks was a thing I photographed a lot. It was one of the first things I photographed and it had a terrific kind of excitement for me."

Another type of acceptance found in the artistic practice of photography is an all-embracing attitude based on the recognition that all subjects are worthy of attention. Cartier-Bresson equates such acceptance with an affirmation of all of life. As he so enthusiastically proclaims, "Photography is like that. It's 'yes, yes, yes.'... It's a tremendous enjoyment to say, 'yes!' Even if it's something you hate—'yes!' It's an affirmation. Yes!" This openness and affirmation of life is very much in accord with the spirit of the *Chuang-tzu*. The accepting attitudes of both Arbus and Cartier-Bresson allowed these photographers to break free of some of the conventions of constricted awareness and to recognize new dimensions of photography and life.

Once a photographer has become more accepting of a wider range of subject matter, exposure to diverse conditions may offer access to new visions of life. Alfred Stieglitz, for example, recalled that when he took his famous photograph of the Flat Iron Building in New York during the snowstorm of 1902–1903, he saw and experienced that building in a new way: "I stood spellbound as I saw the building in that storm.... I suddenly saw the building as I had never seen it before."

On the other hand, a photographer who works only on comfortable sunny, windless days may thereby be excluded from many other dimensions of life, and, consequently, of photographic vision. Rain, wind, lightning, snowstorms, hail, fog, darkness, and other less conventional photographic conditions can inspire photographers to see things freshly, to engage life fully, to see beyond smiling faces and sunny days.

Resourcefulness

*When the monkey trainer was handing out acorns, he said, "You get
three in the morning and four at night." This made all the monkeys
furious. "Well, then," he said, "You get four in the morning and three
at night." The monkeys were all delighted.*

—*Chuang-tzu*

Resourcefulness, which includes the ability to see realms beyond our conditioned, habitual ways of seeing, is another characteristic of the sage found in the *Chuang-tzu*. The sage sees beyond convention; this freedom enables the sage to undertake new and creative ways of thinking and living—to be a constant reservoir of resourcefulness.

In photography, resourcefulness can be described as the capacity to discover new ways of apprehending the world. Thus resourcefulness, although closely related to nonattachment and acceptance, goes beyond them by actively seeking out novel solutions. Consider the following comment by freelance photographer Jerry Jacka: "Many people will go to Monument Valley, and if it's raining or snowing they pack it up and go home. A really serious photographer will make the storm work to his or her advantage." By being caught in the preconceived belief that only clear atmospheric conditions can yield good pictures, inflexible photographers may fail to exploit the unexpected opportunity afforded by "adversity." A Taoistic photographer, like the monkey trainer in the *Chuang-tzu*, does not rebel against the flow of life, but moves with it, finding novel ways to make use of the current.

Photographer Ed Feingersh points out that good pictures are seldom the result of following formulas but, on the contrary, are the result of a "hit"—the spontaneous response that comes from being attuned to the photographic environment:

> Mediocre pictures may follow a formula, good ones seldom do: When
> the visual tools are used just right, the design, lighting, mood, and
> emotion come together to just the right point, and that point hits you
> and you know what the photographer meant—that's a good picture.

In Part II on reconstructing reality we propose some exercises to free up a photographer's vision and promote resourcefulness by encouraging new perspectives, breaking traditional rules of photography, and questioning assumptions. Andreas Feininger says, "Seeing in terms of photography means realizing potentialities: visualizing things not as they are, but as they could be made to appear in picture form."

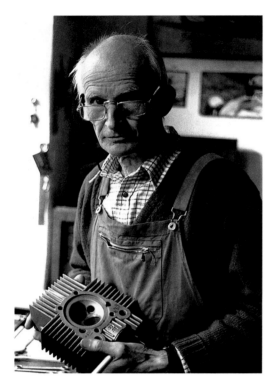

Philippe L. Gross, *Mechanic*
Fribourg, Switzerland, 1992

Te

> *Looking is a gift, but seeing is a power.*
> —*Jeff Berner*

Still another characteristic of the sage found in the *Chuang-tzu* that corresponds to a characteristic of the creative photographer is *te*. This concept is found frequently in the Taoist literature and is generally translated as virtue or power.

When the meaning of *te* is associated with power, it conveys a form of ability, skill, strength, or energy. It is, however, power in the sense of effectiveness or potency without the connotation of domination, rigidity, or self-aggrandizement. Sinologist Angus Graham expresses it this way: "The spontaneous aptitude is the *te*, the 'Power,' the inherent capacity of a thing to perform its specific functions successfully."

Te is certainly evident in the manifestation of the sage's capacity for spontaneous wisdom, but one can also see the concept in the work of artists and artisans. Indeed, the *Chuang-tzu* often provides descriptions of various craftspeople in action. The best known of these is the story of Cook Ting cutting up an ox:

> Cook Ting was cutting up an ox for Lord Wen-hui. At every touch of his hand, every heave of his shoulder, every move of his feet, every thrust of his knee—zip! zoop! He slithered the knife along with a zing, and all was in perfect rhythm, as though he were performing the dance of the Mulberry Grove or keeping time to the Ching-shou music.
>
> ... "I've had this knife of mine for nineteen years and I've cut thousands of oxen with it, and yet the blade is as good as though it had just come from the grindstone. There are spaces between the joints, and the blade of the knife has really no thickness. If you insert what has no thickness into such spaces, then there's plenty of room—more than enough for the blade to play about it.
>
> ... "However, whenever I come to a complicated place, I size up the difficulties, tell myself to watch out and be careful, keep my eyes on what I am doing, work very slowly, and move the knife with the greatest subtlety, until—flop! the whole thing comes apart like a clod of earth crumbling to the ground."

As Cook Ting skillfully and gracefully cuts the ox apart, he surely distinguishes between spaces and joints, but his mind is not attached to their difference. In being fully attuned to the task of cutting the ox, Cook Ting is propelled by *te*. His knife finds its way skillfully between the animal's joints and the ox falls apart effortlessly. As the story illustrates, one imbued with *te* can, according to the *Chuang-tzu*, achieve great results naturally and spontaneously with minimal effort.

In a sense, all the characteristics of the sage are reflections of *te*: they empower the sage with sagacity. When these characteristics are present in the practice of conscious camerawork, they can similarly empower the photographer with photographic sagacity—creative mastery.

In its precise Taoist meaning, *te* (virtue/power) is rarely described by photographers. Nevertheless, glimpses of the concept can be found scattered about in the photography literature. In the following passage, for example, Robert Doisneau describes an experience reminiscent of Cook Ting cutting up an ox:

> There is that moment when we are truly visionary. There, *everything works tremendously well* [emphasis added]. But all this is only a part of that great game that puts us into a trance, into a state of receptivity. This trance doesn't last long, however, because life always calls you back to its commands. There are always contingencies. But somehow, despite it all, the effect does last. I think that it could be classed as a feeling. For me it is a kind of "religion of looking."

Another passage that can be interpreted as an experience of *te* is by George DeWolfe, defining the emotion stirred by capturing a "meaningful experience" in a photograph: "The emotion is one of great humility—and great interior power, of being one with the world." Recall, too, the words of Cartier-Bresson, mentioned earlier in our discussion about the self: "First you must lose your self. Then it happens." The "it" alluded to by Cartier-Bresson could be taken as a manifestation of *te* (power). That is, when the sense of self does not clutter perception, the practice of the liberated photographer can be transformed by *te*—charged with spontaneous, creative power.

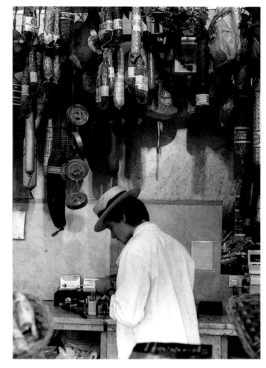

Philippe L. Gross, *Meatdome*
London, 1986

43

AS I PROGRESSED FURTHER WITH MY
PROJECT, IT BECAME OBVIOUS THAT
IT WAS REALLY UNIMPORTANT WHERE
I CHOSE TO PHOTOGRAPH.

—GEORGE TICE

GEORGE A. TICE
Hayfork
Lancaster, Pennsylvania, 1968

Free and Easy Wandering

So the sage has his wanderings.
—*Chuang-tzu*

The sage is often described in the *Chuang-tzu* as a purposeless, free and easy wanderer. The text urges one to "embody to the fullest what has no end and wander where there is no trail." A parallel to free and easy wandering exists in the photography literature, especially in the figure of the *flâneur* photographer. A literal translation of the definition of the French word *flâner* (the verb form of the noun *flâneur*) is "to wander without a goal, at random; to move forward without hurrying."

The expression *flâneur* photographer is used in the photography literature to describe an individual who wanders about with a camera, taking pictures of chance encounters. The nineteenth-century photographer Charles Nègre is probably the first to have been described as a *flâneur* photographer, roaming the streets, "taking pictures of bizarre types and odd encounters." Other French *flâneur* photographers, famous for their compelling street photography, include Edouart Boubat, Henri Cartier-Bresson, Robert Doisneau, and Marc Riboud.

Philippe L. Gross, *Street Scene*
Agra, India, 1986

Although it would be too simplistic to equate a *flâneur* photographer with a Taoist sage, the writings of several photographers suggest that their wanderings could be viewed as Taoistic. When engaged in camerawork, Cartier-Bresson, especially, seems to embody many characteristics of the Taoist sage. Peter Galassi, chief curator in the Department of Photography at the Museum of Modern Art in New York, points out that Cartier-Bresson's free and easy wandering was influenced early on by the surrealist movement which, among other things, favored just such behavior: "Alone, the Surrealist wanders the streets without destination but with a premeditated alertness for the unexpected detail that will release a marvelous and compelling reality just beneath the banal surface of ordinary experience." This description adds a Taoistic flavor to the character of the surrealist *flâneur* by emphasizing lack of destination and relaxed awareness.

The relaxed awareness and purposeless wandering exhibited by Cartier-Bresson and other *flâneur* photographers (e.g., Boubat, Burri, Doisneau, Nègre, Riboud, Uzzle, and Winogrand) suggests that both the unconstricted photographer and the Taoist sage may engage in purposeless wandering. Attuned to the ever-changing environment, they can respond to it naturally, creatively, and spontaneously.

Incorporating Taoist Principles in Photography

We have shown how the characteristics of sagehood described in the *Chuang-tzu* can sometimes be matched in the literature of photographic artistry. The resemblance, however, should be somewhat qualified.

To begin with, our quotations from the photography literature are selective. If they give the impression that most professional or successful photographers are Taoistic, alas, this is hardly the case. Renowned photographers can be controlling, self-absorbed, goal-oriented, entangled by technique, attached to a particular photographic style, or unreceptive to alternative photographic visions. Constricted photographers may be quite successful in their profession, inasmuch as success is so often measured by sales and public exposure (e.g., fashion photography).

Thus, it is only some photographers who at times express their artistic creativity in words reminiscent of the principles of sagehood in the *Chuang-tzu*. Also, we do not suppose that any given photographer expressing Taoistic themes is necessarily aware of them or of their implementation, nor that they will be exhibited consistently in every photograph or in daily living.

Still, we remain impressed by the resemblance found between the sage in the *Chuang-tzu* and some statements of creative photographers. Since only a few photographers are likely to be conversant with an ancient work like the *Chuang-tzu*, what might explain the similarity? Is there a special connection between creative photography and the principles of sagehood as depicted in the *Chuang-tzu*?

Certainly one feature characteristic of most forms of photography—immediacy—constitutes a conspicuous link between the art of photography and the wisdom of the *Chuang-tzu*. Marc Riboud writes, "Taking pictures is savoring life intensely, every hundredth of a second." Ken Ruth says, "For the camera, the creative moment is brief—a compelling, ephemeral collision of event and artist." Cartier-Bresson speaks of the "decisive moment" in photography. Many other photographers also call attention to the brevity of the crucial artistic instant when a photograph is snapped.

BURK UZZLE
Winter Park, 1960

© 1960 Burk Uzzle/Chameleon Photo Inc.

TAKING PHOTOGRAPHS. . .IS A WAY OF SHOUTING, OR FREEING ONESELF, NOT
OF PROVING OR ASSERTING ONE'S OWN ORIGINALITY. IT IS A WAY OF LIFE.
—HENRI CARTIER-BRESSON

HENRI CARTIER-BRESSON
Man Jumping a Puddle
Gare St. Lazare, Paris, France, 1932

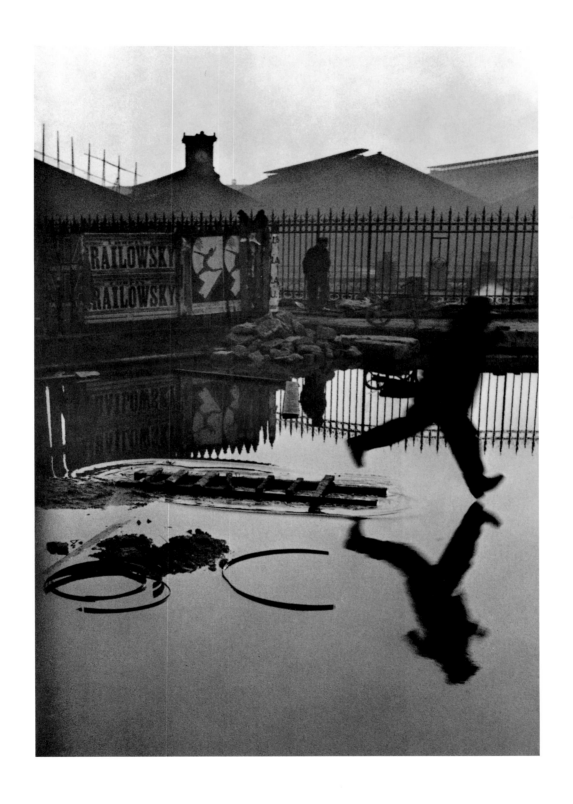

TAKING PICTURES IS SAVORING LIFE INTENSELY,
EVERY HUNDREDTH OF A SECOND.

—MARC RIBOUD

MARC RIBOUD
Worker Painting and Balancing on the Eiffel Tower
Paris, France, 1953

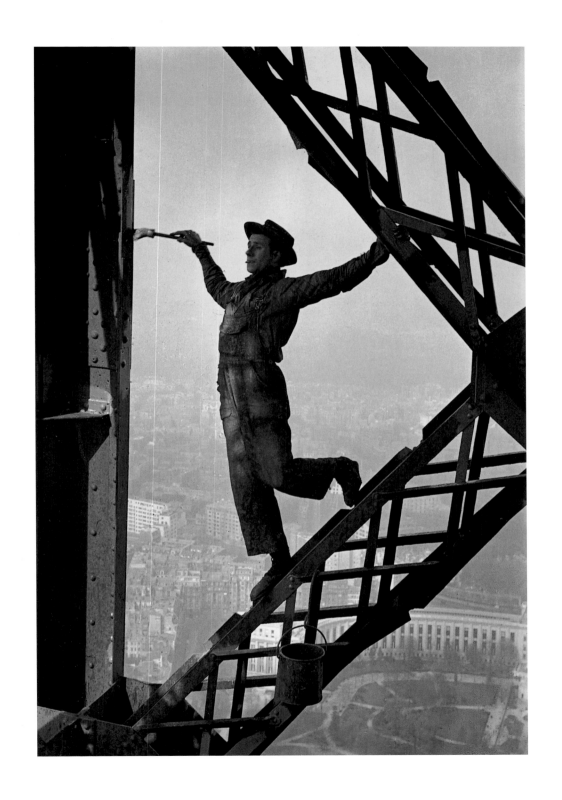

Unlike the photographer, the artist in other media usually has more control over the period of time in which a work of art is created. Creative photography, however, usually necessitates the cultivation of ongoing conscious camerawork in order to instantaneously capture a unique photographic moment. The creative photographer must therefore not only master the art of photography but also the art of mindfulness. In Taoist terms, the photographer must at all times remain attuned to the ceaseless transformations of nature, of all existence.

To mine this boundless treasure of potential photographic moments, a creative photographer can align the self with the Tao. How can this be accomplished? The most direct approach to the Tao is simply to plunge into it—in the words of the *Chuang-tzu*, "Leap into the boundless and make it your home." An easier and more gradual approach is also possible. In order to photograph in the moment, as well as artistically, a creative photographer is likely to have assimilated at least some of the same principles as those of sagehood described in the *Chuang-tzu*. Thus, a natural affinity between the art of sagehood and the art of photography can be said to exist already, one that can be developed further. This leads us to propose that the *Chuang-tzu* could be a very useful instructional manual for teaching creative photography.

Of course the *Chuang-tzu* was composed some two thousand years before the invention of photography, but because creative photography is intimately linked to a moment-by-moment awareness of ongoing transformation there is a natural connection. The creative photographer's life must to some degree become Taoistic, attuned to ongoing change. What better way to strengthen this connection than by becoming directly acquainted with the principles of sagehood in the *Chuang-tzu* and consciously attempting to incorporate them in one's life and camerawork?

Thus, whether or not Taoistic camerawork is the most expedient path to quick, conventional success, we believe that it can help to elicit photographic artistry. Taoistic camerawork is also likely to enhance spiritual understanding, which, like artistry, depends largely upon one's ability to engage life with a receptive mind and unconstricted awareness. Artistically accomplished photographers may discover in the *Chuang-tzu* an ancient and wise companion validating and enriching their artistic intuitions.

Although we feel there is a special connection between the principles of sagehood and those of creative photography due to the fleeting quality inherent in the execution of a photograph, we would certainly not set the art of photography apart from all the other arts in its capacity to evoke the spiritual dimension. Photography shares with other arts the capacity to awaken a boundless, transpersonal universe by such means as generating a breathless moment of eternity, inducing a deep state of mindfulness, sweeping away the self through a sense of awe, or revealing the constructive nature of reality.

PART II

RECONSTRUCTING

REALITY

GARRY WINOGRAND
New York, 1968

© The Estate of Garry Winogrand, courtesy of Fraenkel Gallery, San Francisco

RECONSTRUCTING REALITY

In the twentieth century—in large part because of photography—our awareness of the multidimensionality of the world increased at a striking pace. Photojournalism, nature photography, and scientific imaging expanded our awareness of the universe into hitherto unimaginable dimensions, bringing about significant social, political, cultural, scientific, and technological changes. The revelation of these new levels of reality has also demonstrated what the perennial philosophies have proclaimed for centuries: that our ordinary vision is limited, and that our conventional consensus of reality is not the only version of reality.

The complex multidimensionality of the modern world no doubt contributes to the constructive habit of the mind that, in its attempt to provide meaning, continually rearranges the world to fit individual needs. The failure to recognize the constructive nature of the mind can be a major obstacle to artistry and creativity. Conversely, understanding the constructive nature of mind and reality can lead the way to Great Understanding in the art of photography and in the art of living.

Photography is the ideal medium in which to challenge assumptions, because of all art forms, it is one people most expect to represent reality.... The creative photographer grapples with these expectations, shaping or altering reality by the way he or she approaches a subject.

—Keith A. Boas

Photography and Reality

> *I photograph to see what things look like photographed.*
> —Garry Winogrand

In photography, because the camera usually records an event on film without any apparent interference from the photographer, it is tempting to believe that photographs capture reality in an unbiased way. But, as photographer Henry Emerson explains, this is a naive assumption:

> "A photograph," it has been said, "shows the art of nature rather than the art of the artist." This is mere nonsense, as the same remark might be applied equally well to all the fine arts. Nature

does not jump into the camera, focus itself, expose itself, develop itself, and print itself. On the contrary, the artist, using photography as a medium, chooses his subject, selects his details, generalizes the whole in the way we have shown, and thus gives his view of nature. This is not copying or imitating nature, but interpreting her, and this is all any artist can do.

A quick consideration of some of the factors photographers can vary to create countless images of the same subject illustrates the constructive nature of photographs: composition, lighting, lenses, filters, f/stop, shutter speed, film type and speed, processing. All these factors contribute to the meaning of the final print. Although the constructive nature of photographs is most evident when the artist indulges in digital editing (e.g., combining various photographs into a single image), traditional photography is no less constructive.

Even when we become generally aware that photographs "lie," it is instructive to learn how these lies come about. We once heard a story about Pablo Picasso creating the portrait of a woman in the presence of her husband. The famous painter noticed that the husband was becoming increasingly agitated and inquired about the reason for his uneasiness. The husband responded that the painting did not look like his wife. Picasso replied, "So tell me, what does your wife look like?" The man took a picture out of his wallet and said: "That's how she looks!" Picasso, carefully looking at the picture, then commented, "Oh, really! Small, isn't she?"

The Picasso anecdote, although focused upon the size of a representation (he might have said, "Flat, isn't she?"), illustrates how most of us have learned to read and translate photographs in a way that maintains the illusion that they are somehow true, untransformed representations of reality. The film director Luis Buñuel makes the same point:

> It's hard to imagine today, but when the cinema was in its infancy, it was such a new and unusual narrative form that most spectators had difficulty understanding what was happening. Now we're so used to film language, to the elements of montage, to both simultaneous and successive action, to flashbacks, that our comprehension is automatic; but in the early years, the public had a hard time deciphering this new pictorial grammar. They needed an *explicador* to guide them from scene to scene.

Philippe L. Gross, *One Is Shy*
Honolulu, 1996

I'll never forget, for example, everyone's terror when we saw our first zoom. There on the screen was a head coming closer and closer, growing larger and larger. We simply couldn't understand that the camera was moving nearer to the head.... All we saw was a head coming toward us, swelling hideously out of all proportion.

This anecdote about cinematography is relevant to still photography as well. We interpret physical images in a way that fits a preestablished view of reality. Not only is taking pictures biased or constructed, so is our perception of photographs: a photograph is first constructed by a photographer and then again reconstructed by a viewer. Let us suppose that it was somehow possible to capture a true slice of time—that is, a three-dimensional block in which size, color, texture, and shape would be an exact replication of an actual past event. This perfect replication would still have to be exposed to the subjective interpretation of a viewer. Although the following anecdote involves moral issues in the art of painting, it also illustrates the nature of the reconstructive process in viewing a photograph:

THE CAMERA IS MY TOOL. THROUGH IT I GIVE A REASON TO EVERYTHING AROUND ME.
—ANDRÉ KERTÉSZ

ANDRÉ KERTÉSZ
Disappearing Act, 1955
Collection Patrimoine 1, Paris
© Ministère de la Culture—France

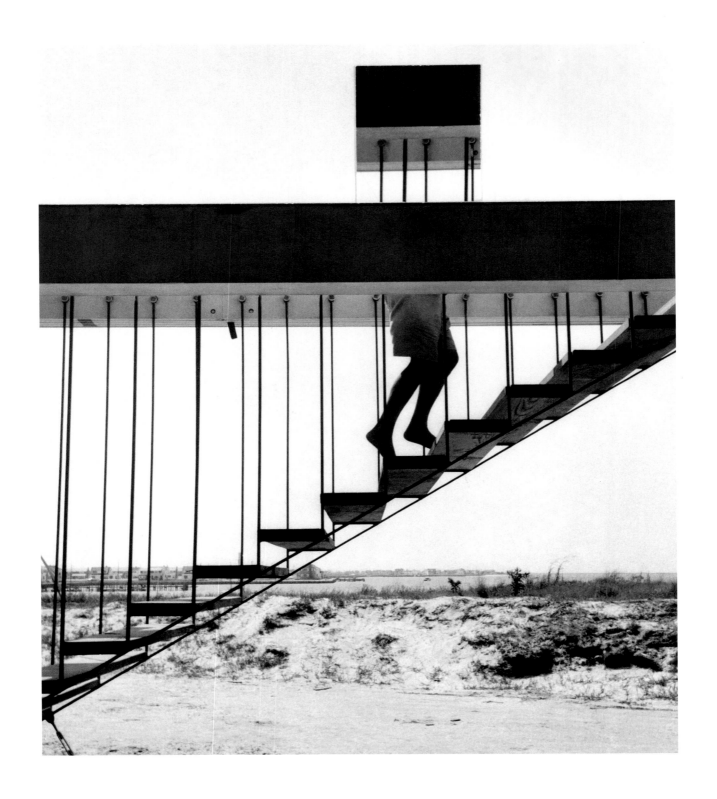

THE CAMERA IS NOT MERELY A REFLECTING
POOL AND THE PHOTOGRAPHS ARE NOT
EXACTLY THE MIRROR, MIRROR ON THE WALL
THAT SPEAKS WITH A TWISTED TONGUE.
—LEE FRIEDLANDER

LEE FRIEDLANDER
Canyon de Chelly, Arizona, 1983
© Lee Friedlander, courtesy of Fraenkel Gallery, San Francisco

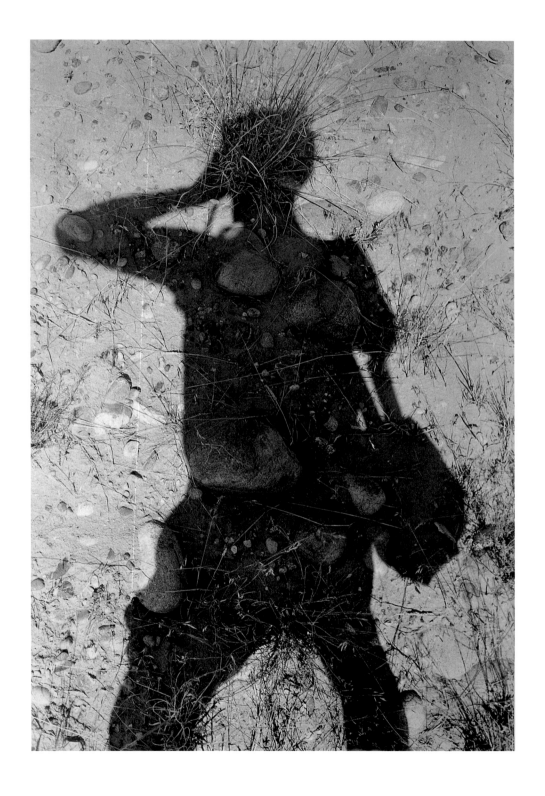

Toulouse-Lautrec once exhibited a painting of a man in an overcoat and hat standing in a room with a half-dressed woman. A *grande dame* took one look and cried, "Obscenity! A woman undressing in front of a stranger!" Whereupon the artist replied, "Ma-da-me, the woman in my picture is not undressing, she is dressing, and the man is not a stranger, he is her husband. Obscenity is in the eye of the beholder, and I'll thank you to stop looking at my painting!"

Furthermore, the reconstructive process is influenced not only by individual biases but also by the context in which a photograph is seen. Literary critic Susan Sontag uses the famous photographs by W. Eugene Smith of the Japanese village of Minamata (where mercury poisoning from industrial wastes caused deformities in children) as an example of the effect of context:

> Smith's Minamata photographs will seem different on a contact sheet, in a gallery, in a political demonstration, in a police file, in a photographic magazine, in a general news magazine, in a book, on a living-room wall. Each of these situations suggests a different use for the photographs but none can secure their meaning.

The notion that photographs are a construction rather than a representation of nature, and that viewers reconstruct photographs in ways that are individually meaningful to themselves, is echoed in the *Chuang-tzu*, which asserts that our understanding of the world is based upon mental constructions rather than on a veridical representation:

> A road is made by people walking on it; things are so because they
> are called so. What makes them so? Making them so makes them so.
> What makes them not so? Making them not so makes them not so.

The constructive approach to reality is not limited to the production of art; it is a commonly prevailing state of mind—Little Understanding, that is, the mind state of constant discrimination. Moreover, when Little Understanding is in control, it constricts the art of living—the Way of life. When the discriminatory state of mind is recognized, however, one can become free from its entanglement, experience Great Understanding, and "wander in the Great Void."

We can translate Great Understanding in terms of photographic practice. When the constructive nature of photography is realized, the photographer can more freely explore new visions, even, ultimately, "wander in the Great Void." In the words of Andreas Feininger:

> Once a photographer is convinced that the camera can lie and that,
> strictly speaking, the vast majority of photographs are "camera lies,"
> inasmuch as they tell only part of a story or tell it in distorted form,
> half the battle is won. Once he has conceded that photography is
> not a "naturalistic" medium of rendition and that striving for "natu-
> ralism" in a photograph is futile, he can turn his attention to using a
> camera to make more effective pictures.

A photographer who becomes aware of the constructive nature of images can be emancipated from the conviction that there exists an ideal way to photograph a subject. New visual avenues in photography emerge, even a more open appreciation of the world in general. As the *Chuang-tzu* suggests, an awareness of the constructive nature of reality facilitates the recognition that there is no ultimate, fixed method in the art of living. No longer bound by the rigidities of the past, a person is freed to live creatively and harmoniously, to assume the role of a happy wanderer through life.

TO ME, PHOTOGRAPHY IS AN ART OF OBSERVATION. IT'S ABOUT FINDING SOMETHING INTERESTING IN AN ORDINARY PLACE.... I'VE FOUND IT HAS LITTLE TO DO WITH THE THINGS YOU SEE AND EVERYTHING TO DO WITH THE WAY YOU SEE THEM.

—ELLIOTT ERWITT

ELLIOTT ERWITT
Pigeon in Flight
Orleans, France, 1952

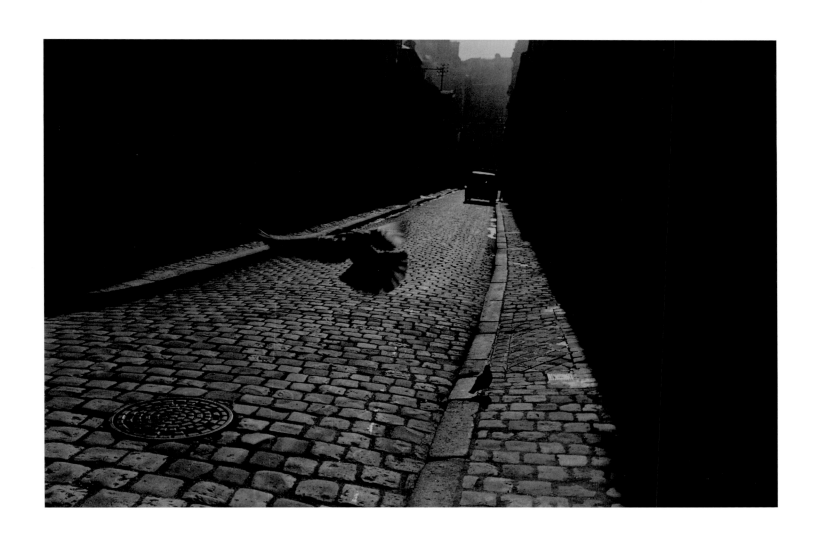

Changing Perspective

When out photographing, it's with a sense of play: no bounds are in sight, anything is possible, and the unexpected welcome.
—Chip Forelli

We all know how to reconstruct reality. We all delighted doing it when we were kids, pretending to see or seeing things invisible to others. Socialization and communication, however, introduced a different agenda and began to mold perceptual conformity. Our reconstructing skills were lost. Photography is one way to regain them.

Reconstructing reality can involve viewing a subject from unusual angles, with different magnifications or types of lighting. Derek Doeffinger, for example, suggests that "instead of seeing the horseness of a horse, you might see it as a landscape—the prairie of its back rising into a mountainous neck. Or you may see it as a temple supported with four slender columns."

The practices that we are about to outline should be approached in a spirit of play—as an invitation to experience the pleasure of seeing things freshly and creatively. Four techniques that can be used to practice reconstructive skills and free ourselves from stereotypic vision are changing perspective, rule-breaking, *dépaysement*, and juxtaposition. Try each of them with relaxed awareness. Most importantly, have fun.

Changing perspective often allows us to see things freshly, offering insight into what was dismissed before as already known. In photography, for example, one can facilitate freshness in seeing by either (a) adopting a new eye level or (b) changing the visual angle through the use of lenses with various focal lengths.

ADOPTING A NEW EYE LEVEL

Pretend to be shorter, taller, different. Go to unusual places. Look at your surroundings from uncommon perspectives. Be a cockroach: crawl under the bed, hide in a closet, and observe your environment with a cockroach's eyes. Be a bird: sit on a branch and look around with your bird's eyes.

Explore new avenues. How would a cat lying on a car's hood see a parade? What is the last thing a mosquito sees before smashing into a car's windshield? What would a grasshopper see peering up through blades of grass? How do trees look from an owl's perspective? What does the proverbial chicken see before crossing the road? And what does the salad in your refrigerator see when you open the door?

Expand your repertoire of photographic positions: kneel, squat down, lie on your back, on your side, on your stomach. Stand on your head and watch how the world changes.

Finally, avoid stiffness. Approach your subject quietly and move around it, under and above it, then back off and observe how the background changes. Keep moving and observe how new relationships can be created by changing your eye level. Notice how the cup of tea in the background can suddenly become a skyscraper by simply stepping a little bit closer or viewing it from below. Experiment with the juxtaposition of objects, create a new world, permit yourself to see as never before. See the world dance.

Philippe L. Gross, *Lotus*
Fribourg, Switzerland, 1999

CHANGING LENSES

Changing lenses causes major shifts in perception, running up and down the ratios of person-to-universe intimacy, altering sensory awareness almost as with Alice in Wonderland as she obeyed the signs that said EAT ME and DRINK ME.

—Jeff Berner

Sometimes we feel limited by the camera's narrowed angle and become frustrated that everything cannot be captured at once. Camera manufacturers have helped us to satisfy our visual gluttony by offering a rich variety of wide-angle lenses and panoramic cameras. Sometimes, though, when too much is included in a picture, less is seen: we see the forest but not the trees, and certainly not the bird hiding in the leaves.

Changing to a narrower lens can bring us closer to the forest and allow us to see the trees, the bushes, the swarming life that gives the forest its luxuriant soul. Textural richness becomes apparent, a host of details previously concealed suddenly emerge to surprise and delight us. Seeing less, we see more.

But don't throw away your wide-angle lenses: every angle can show us mysteries. The idea here is to not be attached to one particular way of seeing. As a practical exercise, next time you take a picture in your habitual way, replace your lens with one you would be less likely to use in that situation and compose another picture. You may see a subject in a new light or details that escaped your attention during the first shot.

ANYTHING THAT EXCITES ME FOR ANY REASON, I WILL PHOTOGRAPH; NOT SEARCHING FOR UNUSUAL SUBJECT MATTER, BUT MAKING THE COMMONPLACE UNUSUAL.

—EDWARD WESTON

EDWARD WESTON
Pepper #30, 1930

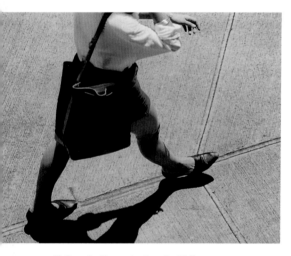

TOP: Philippe L. Gross, *Against the Wall*
San Francisco, 1998

BOTTOM: Philippe L. Gross, *Stride*
Honolulu, 1994

RULE BREAKING

In *Photography and the Art of Seeing*, Freeman Patterson recommends writing down a list of all the rules we assume to be true of photography... and then breaking them. Here are ten rules that recur again and again:

Rule 1: Focus on the center of interest.

Rule 2: Fill in the frame with the subject.

Rule 3: Do not shoot between 10 A.M. and 3 P.M. (The light is too harsh.)

Rule 4: Do not shoot against the light.

Rule 5: Hold the camera steady.

Rule 6: Follow the "rule of thirds": e.g., $1/3$ sky and $2/3$ land or $2/3$ sky and $1/3$ land.

Rule 7: Obey the light meter.

Rule 8: Photograph children (and pets) at their own eye level.

Rule 9: Avoid lens flare when shooting against the sun.

Rule 10: Keep the camera level with the horizon.

Breaking the rules:

Rule 1: Keep the center of interest out of focus; play with the balance of forms.

Rule 2: Allow space around the subject; look for interaction with the environment.

Rule 3: Shoot on any day, at any time.

Rule 4: Photograph only against the light for a month.

Rule 5: Shoot while jumping up and down or spinning around.

Rule 6: Vary your composition. Respond emotionally.

Rule 7: Disobey. Mess up the zone system. Overexpose and underexpose by three, even four f/stops.

Rule 8: Move up, down, on the side, all over.

Rule 9: Use lens flare to enhance a composition.

Rule 10: Create your own horizons.

Now examine the results. You might follow Freeman Patterson's advice to first evaluate your shots emotionally or intuitively to avoid rejecting them as disasters. You can analyze them more formally afterward to discover why some effects are more appealing than others.

DÉPAYSEMENT AND JUXTAPOSITION

Photographs can also challenge our assumptions of the world by making unexpected connections. A photographer can bring together seemingly unrelated ideas, objects, or events in a way that leads to a new conception.
—Keith A. Boas

During the surrealist period, two strategies were often used to challenge assumptions. The first was *dépaysement*, defined by Peter Galassi as uprooting "an ordinary fact or incident from its expected spatial or narrative context, thus releasing a hidden poetic force." Galassi explains that this is true of all photographs because they are always "details, framed and dismembered from the world at large." But the degree of *dépaysement* can vary. For example, Galassi points out that Cartier-Bresson "applied the principle with radical concision, often denying the viewer the bare minimum of clues necessary for a plausible reconstruction of the broad scene from which the cryptic detail had been snatched." Another master of this surrealist strategy is Ralph Gibson. His image, *La Luna*, on the following pages is a striking example of how a new poetic force can be released by uprooting the mouth and nose from the rest of the face. The same principle can be applied as an exercise to all parts of the human body or to animal portraiture.

1. Focus your attention on an event or a scene (for example, someone throwing a ball in the air).

2. Analyze the elements that are essential for the scene to impart its first-level meaning. (In the ball example, both the person and the ball are essential elements for the meaning—a person throwing a ball in the air.)

3. Use your camera to frame only one of the essential elements (for example, the person throwing her arms toward the sky—the ball being out of the frame).

Philippe L. Gross, *Merger*
Honolulu, 1999

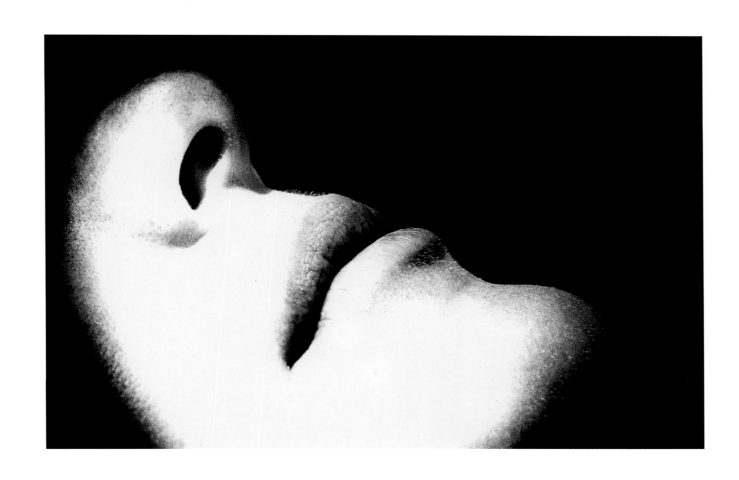

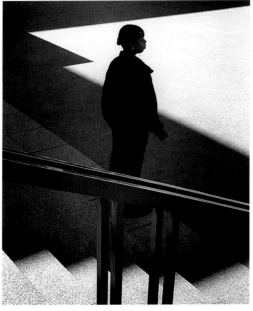

TOP: Philippe L. Gross, *Three Onlookers*
Zurich, 1995

BOTTOM: Philippe L. Gross, *First Step*
Chicago, 1999

This exercise compels you to reinterpret a scene in new and original ways. In the ball example, the behavior cannot easily be explained away because it lacks contextual clues. The new framing, therefore, invites the observer to either impart new meanings to the scene or to appreciate the event for itself without further explanation. As psychologist Abraham Maslow once said, "Something experienced is its own explanation."

The second method frequently used by surrealist artists is juxtaposition, achieved through their favored technique, the collage. By uprooting and grafting together two or more incongruous fragments of reality, the surrealists create a new reality whose "improbable meanings," Galassi explains, are "proof that the logic of ordinary meaning is false." Photography offers an alternative approach to collage. In fact, because a photograph collapses three dimensions into two, a photograph is always a juxtaposition of some sort. While this phenomenon is ordinarily regarded as a liability by many photographers, others, like Cartier-Bresson, Galassi points out, took it as an asset—"incorporating the artificial technique of collage into the realist vocabulary of straight photography."

The reason juxtaposition is conventionally regarded as a liability is because it occurs whether or not the photographer is aware of it. For example, when a photographer fails to notice the background when taking a portrait, the subject may end up looking as though there is a tree coming out of its head. Conscious application of the technique of juxtaposition, however, requires constant awareness of the interaction between background, foreground, and middle ground and a conscious decision to use such collapsing effects either to impart new meaning to a scene or to accentuate its original meaning. To appreciate further the benefits of juxtaposition, try the following exercise:

1. Put a wide-angle or regular lens on your camera and set it up to its smallest aperture so that maximum depth of field is available. (Since you will need a long shutter speed to compensate for the small aperture, a faster film or a tripod is recommended.)

2. Pick a scene and level your camera so as to include a background and a foreground. (Include a middle ground, too, if possible.)

3. Move the camera around while being aware of the juxtaposing effect of the various grounds. (Use the "preview lever" to facilitate your task.) Continue exploring until you find your picture.

PART III

BARRIERS TO
SEEING

ROBERT DOISNEAU
Le Regard Oblique (Sidelong Glance), 1948

BARRIERS TO SEEING

Artistry in photography requires the ability to achieve a state of unconstricted awareness, free of conventional ways of seeing and thinking. Such a state of mind is also a characteristic of liberated living according to the *Chuang-tzu*, allowing the Taoist sage to "leap into the boundless and make it...home."

Unfortunately there are many barriers to achieving a state of unconstricted awareness. Part III is an exploration of those barriers, for we believe that becoming more conscious of them is an important step toward the liberation of the mind and photographic artistry.

Deficiency-Motivations

Many photographers, including Henri Cartier-Bresson, Jeff Berner, and Freeman Patterson, have claimed that the need to control is the greatest barrier to seeing. According to the psychologist Abraham Maslow, the need to control a situation rather than be receptive to it is often driven by "deficiency-motivations," which are primarily related to an individual's need of psychological safety and security. Maslow contended that someone motivated only by the need for safety cannot become fully actualized. From Maslow's list, we have selected nine detrimental motivations that appear to us most relevant to the practice of seeing with unconstricted awareness in the context of photography.

1. *The need to conform, to win approval, to be a member of the group—inability to disagree, to be unpopular, to stand alone.*

 This motivation characterizes the constricted photographer very well. Andreas Feininger depicts the conformist this way:

 > In photography, it is he who is responsible for the majority of mind-
 > less photographs. He is the joiner, the imitator, the photographer

In all things, the Way does not want to be obstructed, for if there is obstruction, there is choking; if the choking does not cease, there is disorder; and disorder harms the life of all creatures.

—CHUANG-TZU

Philippe L. Gross, *Window*
Florence, Italy, 1999

who plays it safe. Such people have surrendered their individuality in exchange for approval, approval by the system, the organization, public opinion, their fellows at the photo club. They have succumbed to fads and trends, they are the in-people who belong to a group or school, and they look down on anybody who does not belong.

Feininger also explains why such a conformist attitude endangers artistic and personal growth:

> Photographers who identify with special groups where everybody follows the same line of thought are deprived of the stimulating criticism and exchange of controversial ideas necessary for the intellectual and spiritual development of any human being.

The motivation to please others by conforming to preset norms or group pressure not only prevents the exploration of new photographic avenues, it also constricts the photographer's awareness within the limitations of visual patterns that have already been popularized by other photographers.

2. ***Overrespect for authority, for the great man. . . . Becoming only a disciple, a loyal follower, ultimately a stooge, unable to be independent, unable to affirm oneself.***

 This attitude is similar to that of conformism. When photographers are too respectful of authority, they limit themselves to preestablished rules and thereby relinquish opportunities for breakthroughs. When 35mm cameras were despised as amateurish, Cartier-Bresson chose one as his main tool and achieved legendary success with it; when color photography was not yet recognized as a valuable medium of artistic expression, Eliot Porter and Ernst Haas mined its possibilities with great success. While most photographers comply with the "sacrosanct rule" of not shooting against the light, Sebastião Salgado has created his greatest work by repeatedly ignoring this rule.

3. ***The ability to be only active, dominant, masterful, controlling, in charge, "masculine," and the inability to be also noncontrolling, noninterfering, receptive.***

 Controlling attitudes, in the opinion of Robert Doisneau, decrease one's ability to "catch life." In the following passage, he describes the difference between controlling photographers and receptive ones:

The Americans who arrived in France after the Liberation…had so much material. They couldn't work without having three flashes. But life passed them in front of their eyes. Naturally, they only photographed the "accepted" things. Whereas someone like Henri [Cartier-Bresson] understood very quickly that you have to have a small, quiet camera and that freedom helped him produce wonderful new pictures.

The ability to be noncontrolling is best described by Cartier-Bresson in the following passage from his seminal work, *The Decisive Moment*:

> It is essential…to approach the subject on tiptoe—even if the subject is still-life. A velvet hand, a hawk's eye—these we should all have. It's no good jostling or elbowing. And no photographs taken with the aid of flashlight either, if only out of respect for the actual light—even when there isn't any of it. Unless a photographer observes such conditions as these, he may become an intolerably aggressive character.

Philippe L. Gross, *Michel*
Fribourg, Switzerland, 1980

4. Underrespect for authority. The need to fight authority. The inability to learn from one's elders or teachers.

Photography is a visual, symbolic language whose vocabulary and grammar can be developed by studying classical masterpieces and by interacting with more advanced photographers or artists. The ability to learn from one's elders or teachers may be crucial in developing one's perceptual skills. Cartier-Bresson is a good example of a famous contemporary photographer who was open to learning from his elders, especially from the old masters of painting.

5. Knowledge and truth may be feared, and therefore avoided or distorted, for many reasons.

Following Maslow's assertion, it is reasonable to suggest that some photographers could gain valuable insights by exploring their capacity to embrace life at its fullest, including less inviting subject matter such as suffering, violence, and death.

WE LOOK AT THE WORLD AND SEE WHAT WE HAVE LEARNED TO BELIEVE IS THERE. WE HAVE BEEN CONDITIONED TO EXPECT....BUT, AS PHOTOGRAPHERS, WE MUST LEARN TO RELAX OUR BELIEFS.

—AARON SISKIND

AARON SISKIND
New York 1, 1947
Courtesy George Eastman House

6. Rubricizing, i.e., pathological categorizing as a flight from concrete experiencing and cognizing.

Doisneau explains that as a photographer his role is to challenge those involved in excessive rubricizing:

> I am the village idiot who goes off to the forest and comes back with a bird in his hat and walks around everywhere saying, "Look and see what I've unearthed!" And this bird of an unknown species immediately bothers notable people simply because they don't know how to categorize it. They never saw that kind of bird before, so they say: "Yes, it's amusing. Now go play elsewhere and let us be, because we're talking about serious things." This is a bit like the photographer's role now.

The cognitive need to categorize and label, says Frederick Franck, author of *The Zen of Seeing*, deprives us of fully experiencing life: "By these labels we recognize everything but no longer see anything. We know the labels on all the bottles, but never taste the wine." As a way to remove these rubricizing barriers, the impressionist painter Claude Monet advocated that "to see we must forget the name of the thing we are looking at."

7. Intolerance of ambiguity: the inability to be comfortable with the vague, the mysterious, the not yet fully known.

This pathology is similar to the preceding one in that it may also involve compulsive rubricizing as a way to evade what is vague or mysterious. Freeman Patterson suggests that when confronting the unknown one should use the imagination rather than labels. He advises students to explore pictures in a variety of media and use them to stimulate the imagination:

> Don't ask for a verbal explanation of a visual puzzle. Resist the label! If you don't recognize the subject matter, make of it whatever you want. Use your imagination. Let your eyes roam over the shapes, colours, lines, and textures. Ask yourself what you like about the picture. Does it make you feel happy? Be willing to respond emotionally.

Philippe L. Gross, *Light Ray*
Honolulu, 2000

Perhaps another way to transcend ambiguity is to embrace Franck's statement: "The inexpressible is the only thing that is worthwhile expressing."

8. Dichotomizing compulsively; two-valued orientation; either-or; black or white.

This attitude is often characteristic of photographers who choose never to deviate from the "rules of composition." Ansel Adams dismissed this outright: "The so-called 'rules' of photographic composition are, in my opinion, invalid, irrelevant and immaterial." Other photographers prescribe greater flexibility: They suggest that the rules of composition are worth studying, but one should be open to breaking them at any time.

9. The need for novelty and the devaluation of the familiar. The inability to perceive a miracle if it is repeated one hundred times.

To remedy this situation, it is necessary to learn how to become more receptive and never to lose the sense of awe.

As our brief survey suggests, deficiency-motivations, like expectations and beliefs, filter the way a photographer perceives the world, constricting the field of awareness to the known and accepted.

ART ALLOWS US TO EXPAND THE DIMENSIONS OF OUR EVERYDAY LIFE.

—CARLOS JURADO

CARLOS JURADO
Manzana, 1975

Philippe L. Gross, *Duel*
Bern, Switzerland, 1999

The Camera as a Barrier

A way of certifying experience, taking photographs is also a way of refusing it—by limiting experience to a search for the photogenic, by converting experience into an image, a souvenir.

—Susan Sontag

The camera can be a valuable way of unconstricting awareness by enabling the photographer to see the environment more directly and fully. At the same time, the camera can also be a photographer's greatest obstacle by constricting awareness to photographic activity alone. If not used mindfully, the camera may become a barrier to both photographic seeing and the photographer's ability to experience life in its fullest.

How does the camera become a substitute for experiencing life fully? (a) Photography can become an attempt to reduce experience to a souvenir; (b) the camera may become a substitute for careful seeing; (c) aesthetic and technical concerns may limit the photographer's engagement with a subject; and (d) the camera can foreshorten an experience by clicking it away.

First, photographing can constrict the photographer's awareness by replacing the experience of the present moment with an anticipated snapshot to be experienced later. This type of constricted experience can be caricatured by the tourists who rush out of the bus, look for the sign that says, "Take picture from here," and then hurry back to the bus that will take them to the next lookout. By not depending on their cameras to record their fleeting visual experiences, such tourists might engage in the scene more fully.

Second, it is all too easy for a photographer to rely on the automaticity of the modern camera and become visually lazy. Ansel Adams suggests that some photographers may have substituted their advanced and sophisticated photographic equipment for careful execution and clear perception: "It's a strange thing that as techniques develop [and] the materials, the lenses, the cameras, get more accurate and perfect, the quality of perception and execution goes down, because they count on the machine to do it." One simple way to overcome the barrier of automaticity is to switch the camera to manual. This forces one to be more involved in evaluating a scene. A very challenging way would be to use the most basic camera, as in the origins of photography. Mexican photographer Carlos Jurado, for example, has been exploring new ways of seeing with pinhole cameras since the early 1970s (see his image on the preceding page).

Third, aesthetic and technical concerns may limit the photographer's engagement with the subject. When photographers become entangled in the desire to produce images only to satisfy their creative or professional needs, they may treat their subjects as mere objects. Michael Freeman points out in *Achieving Photographic Style* that while photography increases sensitivity to the visual aspect of life, it can paradoxically desensitize the photographer to other feelings: "It is not even difficult to reach a stage, with prolific shooting, where the photographer has to wait for the developed film in order to see the events clearly." Freeman provides a revealing example of how overeagerness to capture important events on film may alienate the photographer from life:

> George Rodger, a highly regarded English freelance photographer of the Second World War, was one of the first to enter Belsen concentration camp with Allied troops in 1945. He began work immediately, taking pictures of the bodies, treating the occasion as a source of pictures rather than reacting to the horror around him. When he realized what he was doing, he decided that his days as a war photographer should end.

Dominated by Little Understanding, a photographer can become too concerned with productivity, neglecting to connect to the world and portray its humanity.

Fourth, the camera can shorten the experience by clicking it away. Even when a photographer is fully experiencing a scene through the viewfinder, the action of taking the picture may abruptly end this "unitive" experience. Berner, epitomizes this interruption as "the click that kills":

> When making a picture, the sound of the shutter can "click off" the scene. One immediately turns to look for the next thing to shoot. To avoid killing what you behold, *linger* on it. Not merely saving the view for posterity, but *savoring* it in the now is the only antidote to this subtle occupational hazard.

In summary, when the photographic act becomes an attempt to convert experience into a souvenir, when automaticity replaces careful seeing, when aesthetic and technical concerns override experiencing the subject, or when the click of the camera "kills" the unitive experience between photographer and subject, the camera becomes a barrier to unconstricted awareness rather than an aid. In surrendering full

Complicated equipment and light reflectors and various other items of hardware are enough, to my mind, to prevent the birdie from coming out.

—HENRI CARTIER-BRESSON

93

experience of the moment to the camera, the photographer misses the chance of engaging the receptive mode of Great Understanding, and thereby the ability to feel and respond spontaneously and holistically to a photographic opportunity.

PRACTICE

Outdoor photographer J. D. Marston shares a personal practice that acts as a reminder to free oneself from seeing only in photographic terms. Marston explains that like a Navajo weaver who intentionally inserts a mistake in a weaving so that the soul will not get caught in the finished rug, he deliberately breaks the pattern of his work:

> I'll simply put my camera down and let a good one get away. "How can you do that?!" reverberates in my ears. I may respond with a shrug and a smile, but inside I know that I don't want my soul to get caught in the tapestry of being a professional photographer— whose only way to experience Life is through a viewfinder.

Overstimulation

> *Sometimes I have taken photographs and just felt so excited that I could barely hold the camera steady, and the photo was boring.*
> —*Robert Rauschenberg*

Overstimulation may be of two types. A person can either be overstimulated by an abundance of stimuli (e.g., a hot, noisy, crowded, and fishy-smelling marketplace) or by the intensity of a particular stimulus (e.g., a very attractive face).

Patterson discusses how overstimulation of the first type may constrict awareness:

> We are so bombarded with visual and other stimuli that we must block out most of them in order to cope. Instead of seeing everything, we select a few stimuli and organize these. Then, once we have achieved order in our lives, we stick with the realities we have established. We seldom try to rediscover the possible value of ignored stimuli, and are reluctant to do so as long as the old ones still seem to be working. We develop a tunnel vision, which gives us a clear view of the rut ahead of us, but prevents us from seeing the world around us.

The second type of overstimulation is caused by the intensity of a particular stimulus. As Feininger explains, "Experience has shown that the more fascinating the subject, the less observant the photographer." He describes a session on nude photography in which students were so absorbed by the model that they ignored the background—the pictures awkwardly included other students, lightstands, electric wires, the blackboard, and even the teacher. As a result, "the subsequent criticism of the accomplished work understandably left most of the participants with very red faces."

Action photography and dangerous situations are other examples of conditions in which overstimulation can constrict the photographer's awareness. On a hiking trip in the Sierra Nevada, I suddenly found myself close to a rattlesnake. It was shaking its tail, ready to strike. I grabbed my camera and focused on the snake. I felt intense excitement; this was going to be a great shot. In the face of possible death, everything seemed especially alive. Eventually, when I got to see the developed slides, I was very disappointed—the snake was barely discernible, its color perfectly matching the background.

PRACTICE

To remedy the shortcomings of overstimulation, Feininger urges students to recognize the difference between seeing with our eyes and seeing with a camera:

> The eyes, under the direction of the brain, are selective, consciously noticing only those aspects of reality in which the person is interested, and paying no attention to the rest. In contrast, the camera, being a machine, sees objectively, noticing and recording on film everything within the angle of view of the lens, the important as well as the superfluous and the aesthetically disastrous. Therefore, the photographer must consciously observe every aspect of the scene before he fixes it irrevocably on film.

Visual Aesthetic Biases

A remaining barrier to seeing consists in favoring, consciously or unconsciously, some visual elements at the expense of others. Visual biases can deprive a photographer of the power to see critical elements in a scene. For example, images constantly dominated by lines and texture may indicate a photographer's lack of awareness of pattern,

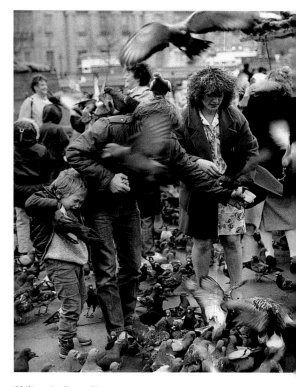

Philippe L. Gross, *Pigeons*
Trafalgar Square, London, 1986

95

ROBERT RAUSCHENBERG
Quiet House, 1949

shape, or color. By uncovering personal biases, photographers can expand their visual awareness, enriching both their pictures and their experiences.

Although a photographer may cultivate aesthetic biases as a personal style, ignoring other visual facets can deprive the photographer of other gratifying ways of apprehending the world. Visual biases, Berner explains, can "represent a subtle trap for the creative artist, just as any habit can limit consciousness."

PRACTICE

In *Learning to See Creatively,* photographer Bryan Peterson proposes the following exercise as a way to identify potential visual biases:

> First, gather seventy-five of your pictures, preferably without people in them. Set them aside, take a sheet of typing paper, and draw six columns on it. At the top of each column list one of the following: line, shape, form, texture, pattern, and color. Now begin looking at your pictures, one by one, with a critical eye. Carefully study each one, and make a check mark in the column that best describes the element(s) that dominate the composition. After you've looked through all seventy-five, note which columns have the most check marks. . . . Which columns have the least check marks?

The photographer who wants to further explore new ways of seeing can try a follow-up exercise suggested by Peterson. Noting the neglected elements, (those that scored the lowest), grab a camera and "head out the door with the goal of identifying and isolating these design components."

PRACTICE

Another exercise designed to help the photographer shake off aesthetic biases and loosen the grasp of the discriminatory mind is to deliberately practice "bad art." Try to create at least twenty ugly, aesthetically unsatisfactory photographs. But do this mindfully, otherwise the exercise may be only a waste of film.

Aside from challenging our established sense of aesthetics and forcing us to see things differently, this exercise can sometimes have a paradoxical effect. Deliberately creating something truly bad, we may fail and create a masterpiece. Don't cheat though by trying to do bad art while really anticipating a big artistic reward. Set your heart fully upon creating bad art.

PART IV

TAOISTIC CAMERAWORK: METHOD AND BEYOND

DUANE PREBLE
Tracks
Ohio, 1999
© Duane Preble

TAOISTIC CAMERAWORK:
METHOD AND BEYOND

The bells and stones have voices but,

unless they are struck, they will not sound.

—CHUANG-TZU

In previous sections, both the Taoist sage and the unconstricted photographer were described in their respective roles as embodying the marriage of Little Understanding and Great Understanding. Such a fusion manifests itself in the Taoist sage as wisdom and in the unconstricted photographer as artistry.

In Part I, constricted awareness was said to be at the root of both unliberated photography and, according to the *Chuang-tzu,* unliberated living. Since both unliberated photography and unliberated living share a common nemesis, some underlying dynamics toward liberation might also be similar. Let us therefore look at the *Chuang-tzu*'s treatment of the role of method in becoming a sage, with an eye to applying its wisdom to achieving artistry in photography.

Teaching Artistry in Photography

Aesthetics is for the artists as ornithology is for the birds.
—Barnett Newman

Wide disagreements on how to achieve artistry seemingly exist in the photography literature. Most opinions on teaching photography could be broadly described as advocating either formal or informal learning. One group of photographers distinctly favors formal training. Manuel Alvarez Bravo says, "There is no other art with as great a democratic capacity as photography. Teaching is of vital importance for photography." Henri Cartier-Bresson gives the following more specific guidelines for all education:

> There should be a visual education emphasized from the very beginning in all schools. It should be introduced just like the study of literature, history or mathematics. With a language, everyone learns the grammar first. In photography, one must learn a visual grammar.

Others who are likely to agree with the formal education advocated by Cartier-Bresson are photographers who write books that include the principles of visual design or the technical aspects of photography.

Photographers who favor informal learning, conversely, may claim that artistry cannot be taught at all or that it can only be self-taught. Here are some examples of this view:

> I don't think you can really teach something which is in you. I never had a lesson in photography in my life, except from Esmeralda, in the early days. She showed me how to load the dark slides, but never anything deeper than that.
>
> —GEORGE RODGER

> You can't teach art, so ART SCHOOL is a contradiction in terms.
>
> —DUANE MICHALS

> You learn to see things by practice. It's just like playing tennis, you get better the more you play. The more you look around at things, the more you see. The more you photograph, the more you realize what can be photographed and what can't be photographed. You just have to keep doing it.
>
> —ELIOT PORTER

Another view of informal learning is that it is more important to focus on the photographer's life enhancement—personal development and understanding. According to some critics, the "technical" approach has been overemphasized in curricula for teaching photography. Henry Holmes Smith, founder of the Society for Photographic Education, offers this severe criticism: "A lot of education today is time-occupying rather than life-enhancing, and time-occupying is a very bad reason to spend all that money for students or for parents." Smith, therefore, is one of those who advocates a "life-enhancing" strategy; artistry must emerge from personal holistic growth, including the ability to be fully conscious while practicing camerawork. This group proposes that rather than being overly involved in teaching visual design and techniques, a teacher should aim at inspiring students to become more conscious of life through the practice of photography. In the words of the late photojournalist

W. Eugene Smith: "If I can get them to think, get them to feel, get them to see, then I've done about all that I can as a teacher." Other photographers seem to agree:

> First, one must learn how to look, how to love. It's the same with painting and writing.
>
> —JACQUES-HENRI LARTIGUE

> Somebody said recently that the best thing a student could do was to get in some shows and publish a book; but nothing about becoming a human being, nothing about having important feelings or concepts of humanity. That's the sort of thing that is bad education. I'd say be a human being first and if you happen to wind up using photography, that's good for photography.
>
> —HENRY HOLMES SMITH

Notwithstanding the disagreements on how to develop artistry in photography, most photographers would accept that constricted awareness impedes artistry and that achieving a state of unconstricted awareness when engaged in camerawork is essential for artistry. Although they do not use the words "constricted" and "unconstricted awareness," their descriptions of the practice of conscious camerawork often allude to such a pair of polar concepts.

Constricted awareness, as discussed in Part I, is at the root of both unliberated photography and, according to the *Chuang-tzu*, of unliberated living. Because of this common nemesis, the art of photography and the art of living may also share some underlying dynamics of a path to liberation. We will now explore the subject of method from the perspective of the *Chuang-tzu*.

The Method That Can Be Followed Is Not the True Method

> *Paths are made by shoes that walk them,*
> *they are by no means the shoes themselves!*
>
> —*Chuang-tzu*

In searching for a path to liberation, we may be inclined to expect a neat method or formula for achieving this goal. But all goals share a common shortcoming: they are rooted in the discriminatory mind, which has a natural tendency to focus on a

THE MORE YOU PHOTOGRAPH, THE MORE YOU REALIZE WHAT CAN BE PHOTOGRAPHED AND WHAT CAN'T BE PHOTOGRAPHED. YOU JUST HAVE TO KEEP DOING IT.

—ELIOT PORTER

ELIOT PORTER
Bentonite Mounds
Heartnut Desert, Utah, 1963

TO PHOTOGRAPH IS TO HOLD ONE'S BREATH, WHEN ALL FACULTIES CONVERGE TO CAPTURE FLEETING REALITY. IT'S AT THAT PRECISE MOMENT THAT MASTERING AN IMAGE BECOMES A GREAT PHYSICAL AND INTELLECTUAL JOY.

—HENRI CARTIER-BRESSON

HENRI CARTIER-BRESSON
Carnival
Cologne, West Germany, 1953

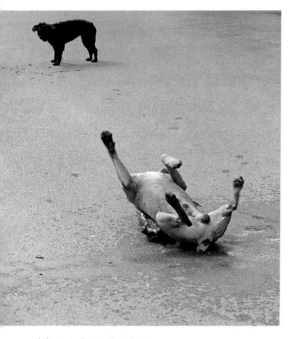

Philippe L. Gross, *Two Dogs*
Vevey, Switzerland, 1995

goal and slavishly strive for it, rejecting anything that appears to impede progress. Singlemindedness may meet with some success in accumulating money or power, but its narrowing, sclerotic character is antithetical to achieving liberation. Because the discriminatory mind constricts awareness, it imprisons the seeker—even the spiritual seeker—in the trap of Little Understanding. Psychologically, one becomes a victim of the "paradox of intention": that is, one's intentional efforts to achieve a goal may be the very obstacle preventing one from reaching that goal.

The paradox arises because the state of mind—determination to solve a problem—fundamentally is the problem in need of a solution. Alan Watts explains:

> There is no way, no method, no technique which you or I can use to come into accord with the Tao, the Way of Nature, because every how, every method implies a goal. And we cannot make the Tao a goal any more than we can aim an arrow at itself.

As well as being an obstacle to liberation, the narrowness of goals and the methods used to reach them can be detrimental to psychological or physical health. A parable from the *Chuang-tzu* provides an unsettling and lethal account about the danger of setting a goal and slavishly pursuing it:

> The emperor of the South Sea was called Shu (Brief), the emperor of the North Sea was called Hu (Sudden), and the emperor of the central region was called Hun-tun (Chaos). Shu and Hu from time to time came together for a meeting in the territory of Hun-tun, and Hun-tun treated them very generously. Shu and Hu discussed how they could repay his kindness. "All men," they said, "have seven openings so they can see, hear, eat, and breathe. But Hun-tun alone doesn't have any. Let's try boring him some!" Every day they bored another hole, and on the seventh day Hun-tun died.

Although Hun-tun's friends intended well, the goal ultimately succeeded only in destroying their benefactor. The message of the *Chuang-tzu* here is clearly that the rigid way of Little Understanding is not the Way.

Inner liberation cannot be sought after by slavish adherence to any set of received teachings or prescriptions, or by simply imitating the characteristics of a sage. Liberation, according to the *Chuang-tzu*, is a natural state of being that emerges when

one is free from subservience to Little Understanding. When such a freedom is secured, Great Understanding can arise naturally and animate the art of living:

> He who understands the Way is certain to have command of his
> basic principles. He who has command of basic principles is certain
> to know how to deal with circumstances. And he who knows how
> to deal with circumstances will not allow things to do him harm.

In being attuned to the Tao, the sage is fully aware of the vital, existential quality of each moment as it participates in the eternal dance of life. Attuned to nature, despite the unceasing and unpredictable undulations of the dance, the sage is never off-balance, never lacks grace, is never short of a "solution."

Insights From the *Chuang-tzu*

> *If the Way is made clear, it is not the Way.*
> —*Chuang-tzu*

We began with an overview of two broadly divergent positions on how artistry in photography can be learned: the formal education approach and the self-taught or the life-enhancing approach. Before continuing, let us consider Wheelwright P'ien's comment from the *Chuang-tzu* on the art of chiseling:

> When I chisel a wheel, if the blows of the mallet are too gentle, the
> chisel slides and won't take hold. But if they're too hard, it bites in
> and won't budge. Not too gentle, not too hard—you can get it in
> your hand and feel it in your mind. You can't put it into words, and
> yet there's a knack to it somehow. I can't teach it to my son, and he
> can't learn it from me.

At first glance, Wheelwright P'ien's comment seems to support the group of photographers who claim that artistry cannot be taught: a photographer must learn through trial and error until a knack for the practice develops. As the French would say, *C'est en forgeant qu'on devient forgeron* (literally, "It is through forging that one becomes a blacksmith"). In English we say, "Practice makes perfect."

WHEN I'M EXPERIMENTING WITH AN IDEA, I'LL DETERMINE THE TECHNICAL ASPECTS WELL BEFOREHAND, SO WHEN I'M SHOOTING, I DON'T NEED TO THINK. THIS LETS ME BE AS RECEPTIVE TO THE MOMENT AS POSSIBLE.

—CHRIS MCDONOUGH

CHRIS MCDONOUGH
Narcissus No. 4
Honolulu, 1997
© Chris McDonough

Granted that practice is necessary for artistry, does it necessarily imply that teaching has no place in making wheels, or in photography? Although Wheelwright P'ien may not directly transmit artistry to his son, he can prepare and guide him in his apprenticeship by teaching him how to use various tools, tips on chiseling techniques, or how to pick the right type of wood for a project. Similarly, in photography, one needs to learn at least how to select and use cameras, films, lenses, and for more advanced practices, artificial lighting, darkroom equipment, and so on. Moreover, as suggested by photographers who emphasize formal education, learning the principles of visual design and studying the approaches of other artists can enrich one's photographic repertoire and elevate the quality and depth of one's artistry.

To be sure, technical knowledge alone does not ensure artistry. As Zen scholar D. T. Suzuki explains, "If one really wishes to be master of an art, technical knowledge of it is not enough. One has to transcend technique so that the art becomes an 'artless art' growing out of the unconscious." Before one can transcend technical knowledge, however, one must have technical knowledge. From this perspective, photographers who advocate formal technical and visual education may be seen as laying down a groundwork on which artistry can subsequently flourish or be enhanced by informal learning.

We can therefore see both educational positions as complementary rather than contradictory. One approach provides the groundwork—with specific guidelines—upon which a photographer can apply the other group's emphasis on informal learning, self-taught or in the form of life enhancement.

Photographers who emphasize visual design and technical knowledge rely more upon Little Understanding; those who emphasize informal learning appear to advocate the perspective of unconstricted awareness, or Great Understanding. Learning here is less concerned about techniques, emphasizing instead the ability to feel or see the world with unconstricted awareness.

Although a teacher can nurture and guide a student's practice, Wheelwright P'ien's comment remains valid: one cannot teach artistry any more than one can teach sagacity. Both artistry and sageness are manifestations of an individual's skills combined with the ability to engage life with unconstricted awareness—in short, the ability to harmonize Little Understanding and Great Understanding.

The practice of conscious camerawork, by itself, can serve as a path toward unconstricted awareness. My first glimpses of this possibility occurred in my own camerawork (see Introduction). Later I found confirmation in the reports of other

photographers like Bill Brandt, who suggests that achieving unconstricted awareness is part of the "photographer's job":

> It is part of the photographer's job to see more intensely than most people do. He must have and keep in him something of the receptiveness of the child who looks at the world for the first time or of the traveller who enters a strange country.

Aside from this "job requirement," it seems that the simple act of seeing the world through a camera lens naturally brings one's mind closer to the unfolding process of existence. In part, this closer contact or heightened awareness may be due to the camera's limitation; it only allows an image to be created within the momentary opening of the aperture. Also, as Jeff Berner points out, "When contemplated through a lens, the world takes on a somehow clearer aura, partly because of the glass but especially because of the focus and concentration of camerawork."

The practice of conscious camerawork as a path to unconstricted awareness need not be exclusive to photographers. Psychologists and spiritual teachers have used camerawork to help evoke a sense of Great Understanding among individuals who had no professional interest in photography.

The idea that practicing conscious camerawork, by itself, can help unconstrict one's awareness and nurture artistry thus accords well with both the *Chuang-tzu*'s view on method (e.g., Wheelwright P'ien) and the view of those photographers who advocate informal learning and practice. Free from entanglement in methods for self-improvement, a photographer can naturally develop artistry by the constant practice of conscious camerawork, including the use of new photographic techniques.

When seen from a panoramic, Taoistic angle, the divergent positions on learning artistry in photography can be reconciled. Although artistry itself cannot be directly taught, the acquisition of techniques coupled with the practice of conscious camerawork can contribute to a photographer's artistry. At the culmination of the learning process, the liberated photographer, harmonizing technical mastery and unconstricted awareness, can be likened to the Taoist sage.

In tune with the ceaseless transformations of life and free of an interposing self, the Taoistic photographer responds effortlessly and spontaneously to any photographic opportunity. In difficult photographic situations, the Taoistic photographer displays resourcefulness. Well-grounded in technique, but unattached to any particular method, the Taoistic photographer apprehends naturally the simplest way to get things done.

I USUALLY SHOOT EARLY MORNING ON WEEK-ENDS.
THAT'S HOW I RELAX. IT'S A MORNING MEDITATION.
—GENE NITAHARA

GENE NITAHARA
Untitled
Belgium, 1972
© 1972 Gene Nitahara

116

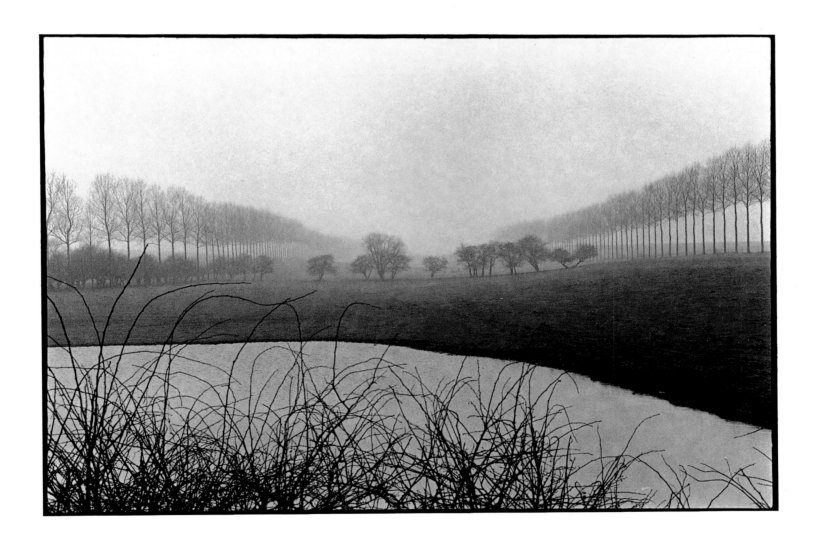

Philippe L. Gross, *Joshua Tree National Park*
California, 1999

The Taoistic photographer is thus not rigidly attached to specific subjects but can embrace them all. Free from the entanglements of Little Understanding, the Taoistic photographer is receptive to and accepting of every aspect of life: seeing wonder everywhere and in everything. Finally, the Taoistic photographer, like the Taoist sage in the *Chuang-tzu*, can spontaneously engage in the art of happy wandering, embodying "to the fullest what has no end" and wandering "where there is no trail."

PART V

THE PATH OF CONSCIOUS CAMERAWORK

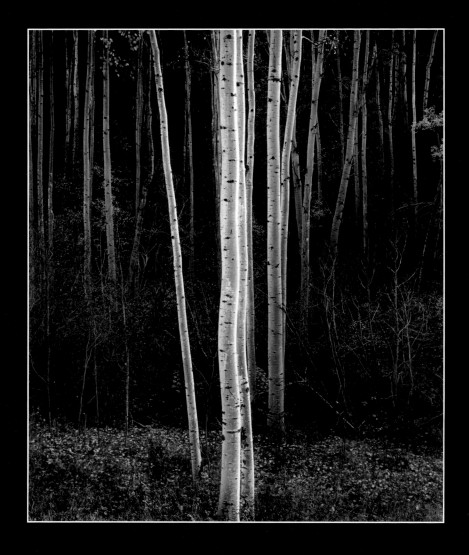

ANSEL ADAMS
Aspens
Northern New Mexico, 1958

THE PATH OF CONSCIOUS CAMERAWORK

Earlier, we outlined and compared the unliberated mind as described in the *Chuang-tzu* with the unliberated photographer, and then discussed some barriers to liberated seeing and photographic artistry. We proposed that the unliberated life suffers from constricted awareness—a product of the discriminatory mind—what the *Chuang-tzu* calls Little Understanding. But we also have discussed another quite different mode of knowing, one the *Chuang-tzu* calls Great Understanding—receptive or unconstricted awareness. The ability to engage life with unconstricted awareness is critical in the art of living; it is no less critical for artistry in photography. In this final section, we will explore further the benefits of practicing conscious camerawork and moving beyond photography to Taoistic seeing and the art of living.

Conscious Camerawork and Mindfulness

Conscious camerawork closely resembles mindfulness meditation as described by psychologist Daniel Goleman. One could replace the word "mindfulness" with "conscious camerawork" and have a quite suitable definition of the latter as well:

> Mindfulness entails breaking through stereotyped perception. Our
> natural tendency is to become habituated to the world around us, no
> longer to notice the familiar.... In mindfulness, the meditator
> methodically faces the bare facts of his experience, seeing each event
> as though occurring for the first time. He does this by continuous
> attention to the first phase of perception, when his mind is *receptive*
> rather than reactive.

The resemblance between the practice of mindfulness and of conscious camerawork suggests to us that they could be either complementary or even alternative methods for personal development. Such an idea seems to have already gained the

The eye that is penetrating sees clearly, the ear that is penetrating hears clearly, the nose that is penetrating distinguishes odors, the mouth that is penetrating distinguishes flavors, the mind that is penetrating has understanding, and the understanding that is penetrating has virtue.

—CHUANG-TZU

attention of a few psychologists and spiritual teachers: they use photography as a teaching device to evoke unconstricted awareness independently of professional photographic objectives.

Jeremy Hayward, education director of Shambhala Training International, for example, provides the following description: "When you take photographs, just before you click the shutter, your mind is empty and open, just seeing without words." Abraham Maslow, the psychologist whose work on barriers we mentioned earlier, recommends exercises to help the learner unconstrict awareness and enter what he calls the "being-realm": one exercise is to "use the artist's or photographer's trick of seeing the object *in itself*." Maslow argues that by framing the object, one cuts it away from its surroundings, and thereby from one's "preconceptions, expectations and theories of how it *should look*." Here are some of Maslow's exercises:

> Enlarge the object. Or, squint at it so you see only general outlines. Or, gaze at it from unexpected angles, such as upside down. Look at the object reflected in a mirror. Put it in unexpected backgrounds, in out-of-the-ordinary juxtapositions, or through unusual color filters. Gaze at it for a very long time. Gaze while free-associating or daydreaming.

John D. Loori is a Zen teacher and photographer who also uses conscious camerawork. Loori says, "The art of mindful photography approaches photography as a life practice, involved not only with the artist's seeing and photographing, but with all aspects of daily living, so that the practice of mindful photography becomes a Way."

Hayward, Maslow, and Loori each suggest that conscious camerawork can help unconstrict one's awareness. We, too, have used conscious camerawork to help students experience unconstricted awareness and spontaneity, and to see the sacred in the ordinary. Some of our students reported that the greater appreciation of life they experienced during conscious camerawork also affected common daily activities.

Can conscious camerawork be used to train mindfulness? Jon Kabat-Zinn, author of *Wherever You Go, There You Are*, defines mindfulness as "paying attention in a particular way: on purpose, in the present moment, and nonjudgmentally." This definition easily meshes with the practice of conscious camerawork, which involves paying attention through a camera in the same way. Kabat-Zinn goes on to

say that mindfulness is simple to practice but not necessarily easy. It requires effort and discipline because "the forces that work against our being mindful, namely, our habitual unawareness and automaticity, are exceedingly tenacious." The goal of mindfulness practice, therefore, is to replace the habit of unawareness by the habit of paying attention.

The practice of mindfulness, especially in the beginning, can be experienced as a conflict between two forces: the will (effort and discipline) to remain consciously aware pitted against the habit of unawareness. To facilitate the practice of mindfulness, one can engage in activities that either reinforce the will to be conscious or reduce the habit of unawareness.

Camerawork practice has the potential to do both. It fortifies the photographer's will to remain alert so that an exceptional moment can be captured on film. And it helps to reduce the habit of unawareness because the camera can only capture an image in the here and now: the photographer is compelled, moment by moment, to remain in tune with the present. As Cartier-Bresson explains, life is fluid and "sometimes the pictures disappear and there is nothing you can do. You can't tell the person, 'Oh, please smile again. Do that gesture again.' Life is once, forever." Camerawork can motivate, even compel, a person to remain acutely conscious and aware, to continually pay attention.

Using camerawork to cultivate unconstricted awareness, to be more attentive and more mindful, does not mean focusing only on the photographic moment "out there." Conscious camerawork also involves sensing, feeling, and thinking. A photographer must be aware not only of external subjects but also of internal phenomena like thoughts, emotions, and sensations, and how they affect photographic vision. As photographer Ralph Hattersley suggests, photographers should "observe themselves as observers and in that way come to understand why they see the way they do." It is important to be aware even of one's physical posture so as to prevent unwanted "camera shake." In short, conscious camerawork involves a complete physical, emotional, and mental awareness so that the photographer does not become entangled in barriers to unconstricted awareness.

One may not even have to be actively involved in taking pictures to train the habit of awareness. Simply the act of carrying a camera around throughout the day, as mentioned in the Introduction, can be used as a mnemonic to keep one's awareness open, to see life unfolding moment by moment.

Seeing is perception with the original, unconditioned eye. It is a state of consciousness in which separation of photographer/subject, audience/image dissolves; in which a reality beyond words and concepts opens up, whose "point" or "meaning" is the direct experience itself.

—JOHN D. LOORI

125

I AM NOT INTERESTED IN SHOOTING NEW THINGS—
I AM INTERESTED TO SEE THINGS NEW.

—ERNST HAAS

ERNST HAAS
Egyptian Boys, 1956

© 1956 Tony Stone

126

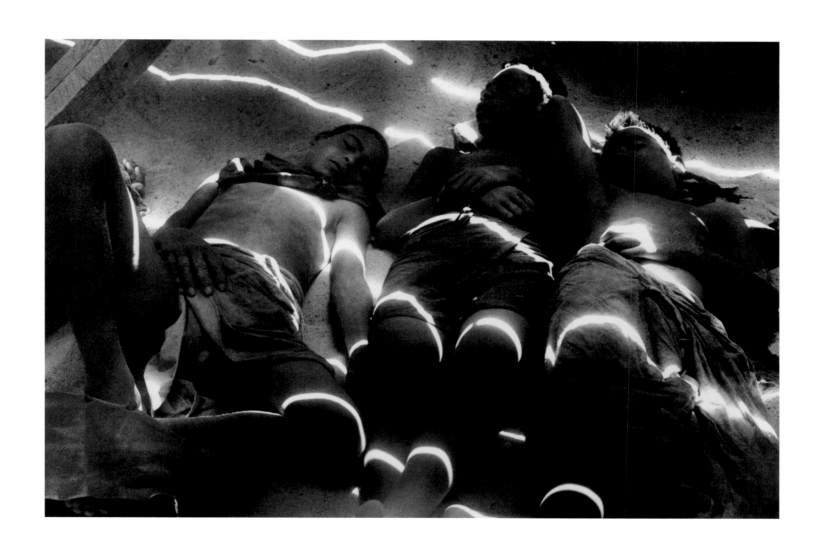

Taoistic Seeing

Ernst Haas once said, "I am not interested in shooting new things—I am interested to see things new." What does it mean "to see things new"?

One approach to seeing things newly is to create a new vision of an ordinary subject. This can be done by viewing it from many unusual angles, with various magnifications, or in different types of lighting—in short, by actively experimenting with novel visual realities. Another approach is to transform the act of seeing itself through undergoing a transformation of consciousness. While techniques for transforming consciousness abound, we have focused on the evocation of unconstricted awareness either through the practice of conscious camerawork or through freeing oneself from subservience to the discriminatory mind.

Both approaches to seeing freshly—constructing new realities or engaging life with unconstricted awareness—are valuable and can provide the seer with a richer and deeper picture of the world. Whereas the first approach provides different perspectives on the world, the second offers a new way to experience the world. Both approaches can prevent the seer from being trapped in any particular vision or construction of reality.

The ability to create or see new realities in a state of unconstricted awareness can also give Taoistic insights into the flowing nature of existence and its ceaseless manifestations. To apprehend and appreciate the Tao in action, the seer must be released from subservience to the discriminatory mind so that it is possible to be receptive to many levels of reality at once. Ultimately the art of seeing can lead to apprehending the Tao in action—to deeply recognizing and experiencing the continuous transformation of the universe. Such apperception lies beyond seeing a person or an object with freshness (i.e., uncluttered by the discriminatory mind). It means seeing every element of the universe collectively undergoing an unending process of change. In the words of the *Chuang-tzu*:

> The ten thousand things are really one. We look on some as beautiful because they are rare or unearthly; we look on others as ugly because they are foul and rotten. But the foul and rotten may turn into the rare and unearthly, and the rare and unearthly may turn into the foul and rotten. So it is said, You have only to comprehend the one breath that is the world. The sage never ceases to value oneness.

We are not interested in the unusual, but in the usual seen unusually.

—BEAUMONT NEWHALL

It may seem ironic or contradictory that detailed pictures of so-called reality become vehicles for moving us beyond ordinary perceptions.

—DUANE PREBLE

The Art of Living

*What ordinary people do and what they find happiness in—I don't
know whether such happiness is in the end really happiness or not.
I look at what ordinary people find happiness in, what they all make a
mad dash for, racing around as though they couldn't stop—they all say
they're happy with it. I'm not happy with it and I'm not unhappy with
it. In the end is there really happiness or isn't there?*

—*Chuang-tzu*

The vision of the *Chuang-tzu* is that every individual is naturally liberated and in harmony with life. But it is all too easy to get caught up in the web of Little Understanding. The art of living, therefore, lies not so much in improving oneself, but in freeing oneself from the entanglement of the discriminatory mind. When such freedom is secured, according to the *Chuang-tzu*, one naturally merges with the Tao.

Earlier, we discussed the concept of *wu-wei* or effortless effort in the *Chuang-tzu*: "Perfect action is the abandonment of action." In the art of living, it is vital to know when to let go.

If we fail to recognize the fundamental transforming nature of life—which includes the self, the environment, and other people—we are likely to fall into the habit of trying to rigidly control everything. But the search to secure and hold fast all matters according to our own needs ultimately must fail: control of the whole of our existence is just out of our control. The futility of this obsessive approach to living is starkly exposed in psychiatrist Gerald May's book *Simply Sane: Stop Fixing Yourself and Start Really Living*. May takes a rather Taoistic position with regard to the dynamics of self-development, psychotherapy, and psychological self-healing: he warns against becoming fixated on fixing, heading down a path of endless psychological fixes. Instead, he calls us back to the voice of sanity, "which seems to be telling us to allow ourselves to be what we are, fully, dynamically and without any great extra meddling." Stepping aside, relaxing the grip of Little Understanding, we can allow Great Understanding to surface. We can then clearly see a problem with all its ramifications: its simplicity and its complexity. Solutions can now appear naturally, effortlessly.

In summary, an obsession with controlling oneself, nature, or others is not likely to succeed in the long run. Conversely, appropriate action naturally emerges when one apprehends and accepts the ceaseless process of existence with unconstricted awareness.

Philippe L. Gross, *Man and Table*
Naxos, Cyclades, Greece, 1994

Perhaps the meaning of life and the art of living are not really so elusive, not so complicated, after all. Could it be that conscious living is both a path and a destination?

We also know that the practice of freeing awareness from distorting influences of the mind can often result in heightened states of awareness. It is not surprising, therefore, that photographers who engage in the practice of conscious camerawork also report experiencing heightened awareness through their work (e.g., Jeff Berner, Bill Brandt, Henri Cartier-Bresson, Robert Doisneau). Most importantly, the ability to experience a heightened state of awareness can significantly enrich one's sense of the meaningfulness of life.

The link between experiencing a more meaningful life and the ability to experience heightened states of awareness is reflected in Abraham Maslow's theory of meta-needs. When a person fails to fulfill the metaneeds (e.g., aesthetic fulfillment, transcendence), he or she may come to experience metapathologies (e.g., existential depression or even the urge to commit suicide). Recognizing the importance of heightened states of awareness for increasing self-actualization and meaningfulness, Maslow spent much of his career studying these states, especially what he called "peak experiences." One of Maslow's striking conclusions is that the meaning of life isn't always tied to goals. When it comes to the art of living, some experiences are simply self-meaningful:

> The peaker learns surely and certainly that life can be worthwhile,
> that it can be beautiful and valuable. There are ends in life, i.e.,
> experiences which are so precious in themselves as to prove that not
> everything is a means to some end other than itself.

Our society is rather heavily goal oriented. People often seek after a series of never-ending, often elusive and unattainable dreams. It's easy to fall prey to Little Understanding and entangle ourselves in the elusive search for more. Long ago, the *Chuang-tzu* warned about the perils of fixed objectives and acquisitiveness:

> He who considers wealth a good thing can never bear to give up his
> income; he who considers eminence a good thing can never bear to
> give up his fame. He who has a taste for power can never bear to
> hand over authority to others. Holding tight to these things, such
> men shiver with fear; should they let them go, they would pine in
> sorrow. They never stop for a moment of reflection, never cease to
> gaze with greedy eyes—they are men punished by Heaven.

130

On the positive side, the *Chuang-tzu* presents us with a radically different view of the art of living. Shocking as it may sound at first, the art of living and the meaning of life both lie in the sheer experience of beingness, and can be reached by simply allowing oneself to be and to relax into the ceaseless process of life. When a photographer comes to experience the intrinsic existential richness and beauty of life by practicing conscious camerawork, the goals of achieving artistic "perfection" and "immortality" may lose some of their appeal. Enjoying the process of existence unfolding for its own sake applies equally to other artistic practices. In *The Importance of Living*, Lin Yutang has this to say:

> Much as I appreciate all forms of immortal creative work, whether
> in painting, architecture or literature, I think the spirit of true art
> can become more general and permeate society only when a lot of
> people are enjoying art as a pastime, without any hope of achieving
> immortality.

The shift of emphasis from being driven by achievement to simply enjoying the process of existence was experienced personally by Maslow after he suffered a life-threatening heart attack: "I am living an end-life where everything ought to be an end in itself, where I shouldn't waste any time preparing for the future, or occupying myself with means to later ends." But one doesn't need to experience a heart attack to find such inner satisfaction. A profound state of fulfillment is already available, simply waiting to be unveiled. Why not forsake the endless pursuit of happiness and bask in the shade of the Tao, the flow of existence?

RENÉ BURRI
Three Men Check Out Two Women Walking
Rio de Janeiro, Brazil, 1960

© 1960 René Burri/Magnum Photos, Inc.

EPILOGUE: SEEING BEYOND SEEING

When one becomes disentangled from the grasp of the discriminatory mind, a different kind of seeing is free to emerge. As a teenager, I unconsciously adopted the belief that some subjects deserved to be photographed more than others. I didn't have a list in mind of what I thought was acceptable or not, but after awhile I noticed that I always seemed to photograph the same cluster of subjects, family, friends, animals, landscapes, or sports events.

One day I had a shocking experience. Someone who had taken a picture of a door won the first prize in a photography contest. I could not believe that such a common subject could be judged worthy of a prize. Of course, that was before I tried to photograph a door. I had no idea how difficult it would be to construct an image that would make an ordinary door interesting. The incident provoked me to pay closer attention to the ordinary. Over time, I began to appreciate, in photography and in my everyday life, a remark made long ago by the ancient Taoist Lao-tzu: "The secret of the Tao is found in the smallest detail of the ordinary day."

As we have seen, in vivid, evocative exposition and anecdotes, the *Chuang-tzu* describes how sagacity and the art of living—the manifestations of "understanding beyond understanding"—flow forth from being in harmony with the Tao. Similarly, conscious camerawork leads to a deeper, more universal way of seeing: we call this "seeing beyond seeing."

The ten thousand things have their life,
yet no one sees its roots;
they have their comings forth,
yet no one sees the gate.
Men all pay homage to
what understanding understands,
but no one understands enough to
rely upon what understanding
does not understand and thereby
come to understand.

—Chuang-tzu

Philippe L. Gross, *Peeking*
Fribourg, Switzerland, 1978

Seeing the smallest dewdrop,
you can stand in awe of perfection.

—JOHN SHAW

An earthy dialogue from the *Chuang-tzu* calls attention to the universal potential for seeing beyond seeing:

> *Master Tung-kuo asked Chuang Tzu, "This thing called the*
> *Way—where does it exist?"*
> *Chuang Tzu said, "There's no place it does not exist."*
> *"Come," said Master Tung-kuo, "you must be more specific!"*
> *"It is in the ant."*
> *"As low a thing as that?"*
> *"It is in the panic grass."*
> *"But that's lower still!"*
> *"It is in the tiles and shards."*
> *"How can it be so low?"*
> *"It is in the piss and shit!"*
> *Master Tung-kuo made no reply.*

For those who understand beyond understanding, who see beyond seeing, the ceaseless process of nature—the Tao—is everywhere, enriching everything. "Leap into the boundless and make it your home!" exclaims the *Chuang-tzu*. Although the *Chuang-tzu* can well serve as an inspiring manual for the art of creative photography, this ancient Taoist text remains foremost an invaluable guide to the art of living. Photographers and nonphotographers alike can take the leap: to enrich their vision, their art, their lives. . . *to see beyond seeing*.

WORKS CITED

INTRODUCTION

Page 1—"Perfect Yin": *The Complete Works of Chuang Tzu*, trans. Burton Watson (New York: Columbia University Press, 1968), 225.

Page 4—"Our personal growth": Brooks Jensen, "How to Make a Workshop Work," *LensWork Quarterly* (Winter 1994), 72.

Page 6—"Above he wandered": *Chuang Tzu*, trans. B. Watson, 373–374.

Page 6—"For the camera": Ken Ruth, "Ken Ruth by Ken Ruth," *Camera & Darkroom* (January 1993), 46.

PART I: PRINCIPLES OF TAOISTIC PHOTOGRAPHY

Page 9—"Leap into the boundless": *The Complete Works of Chuang Tzu*, trans. Burton Watson (New York: Columbia University Press, 1968), 49.

Page 9—"Great understanding": Ibid., 37.

Page 9—"Once there was a man": Ibid., 348.

Page 10—"Arriving at the rim": E. J. Langer, *Mindfulness* (Reading, MA: Addison-Wesley, 1989), 117.

Page 11—"Great understanding": *Chuang Tzu*, trans. B. Watson, 37.

Page 11—"In being one": Ibid., 79–80.

Page 11—"Seeing, in the finest": Freeman Patterson, *Photography and the Art of Seeing* (New York: Van Nostrand Reinhold, 1979), 7.

Page 12—"Forget things": *Chuang Tzu*, trans. B. Watson, 133.

Page 12—"What's more, we go": Ibid., 88.

Page 12—"When you begin": Ken Reno, "The Casual Observer: A Street Photographer's World View," *Camera & Darkroom* (August 1994), 38.

Page 13—"Once Chuang Chou": *Chuang Tzu*, trans. B. Watson, 49.

Page 13—"After probing appearances": Jeff Berner, *The Photographic Experience* (New York: Doubleday, 1975), 124.

Page 13—"There comes a moment": Kathryn Marx, *Right Brain/Left Brain Photography: The Art and Technique of 70 Modern Masters* (New York: Amphoto, 1994), 114.

Page 13—"If we do our job right": Adam Jahiel, "The Cowboy Way: Photographs of the American West," *Camera & Darkroom* (January 1995), 27.

Page 18—"I find that you": Henri Cartier-Bresson [Quote], *Modern Photography* (October 1998), 94.

Page 18— "I'm not responsible": Ibid., 94.

Page 18—"The sage's mind:" *Chuang Tzu*, trans. B. Watson, 142.

Page 18—"With likes and dislikes": Ibid., 141.

Page 18—"It's easy to fall": J. Bell, "Alex MacLean," *Photographer's Forum* (May 1995), 51.

Page 19—"Out in the field": M. Rodriguez, "Keith Lazelle: Capturing Nature at Its Most Quiet," *Camera & Darkroom* (April 1993), 25.

Page 19—"All my photographs": M. E. Harris, "Edouart Boubat and Pierre Gassman," *Camera & Darkroom* (September 1993), 26.

Page 20—"The greater the range": Marx, 52.

Page 20—"A split-second decision": Ibid., 114.

Page 20—"I am not looking": W. McEwen, "Extended Vision: The Photography of Michael A. Smith," *Camera & Darkroom* (July 1992), 36.

Page 21—"Superiors must adopt": *Chuang Tzu*, trans. B. Watson, 144.

Page 21—"responding with an awareness": Roger T. Ames, "Putting the *Te* Back Into Taoism," *Nature in Asian Traditions of Thought: Essays in Environmental Philosophy*, ed. J. B. Callicot and R. T. Ames (Albany, NY: State University of New York Press, 1989), 140.

Page 21—"a course of action": Burton Watson, in *Chuang-Tzu*, trans. B. Watson, 6.

Page 21—"When I photograph": *Photography Speaks*, ed. B. Johnson (New York: Aperture, 1989), 76.

Page 21—*Wu-wei* is thus the life-style": Alan Watts, *Tao: The Watercourse Way* (New York: Pantheon, 1975), 76.

Page 21—"One does not think": Edward Weston, "Thoughts on Photography," in *The Best of Popular Photography*, ed. H. V. Fondiller (New York: Ziff-Davis, 1979), 280.

Page 22—"There are processes": Eugen Herrigel, *Zen in the Art of Archery* (New York: Random House, 1953), 57.

Page 22—"I never look": D. D. Conrad, "Ruth Bernhard," *Camera & Darkroom* (May 1994), 28.

Page 22—"Throughout my life": M. E. Harris, "Manual Alvarez Bravo: The *C & D* Interview," *Camera & Darkroom* (February 1994), 31.

Page 23—"To spend little effort": *Chuang Tzu*, trans. B. Watson, 135.

Page 23— "When you're betting": Ibid., 201.

Page 23— "'The right art' cried the Master": Herrigel, 31–32.

Page 28— "[The sage] constantly goes": *Chuang-Tzu: The Inner Chapters*, trans. A. C. Graham (London: Unwin, 1989), 82.

Page 28— "Even when working": G. Schaub, "Ellen Denuto," *Photographer's Forum* (May 1995), 16.

Page 28—"While all other things": Angus C. Graham, in *Chuang-Tzu*, trans. A. C. Graham, 6.

Page 29—"For me, the camera": Henri Cartier-Bresson, *Henri Cartier-Bresson, Photographer*, rev. ed. (Boston: Little, Brown, 1992), 333.

Page 29—"People who really know": Angus C. Graham, in *Chuang-Tzu*, trans. A. C. Graham, 6.

Page 29—"The Perfect Man": *Chuang Tzu*, trans. B. Watson, 97.

Page 32—"Out of the fullness": Herrigel, 38.

Page 32—"Don't try to subdue": Derek Doeffinger, *The Kodak Workshop Series: The Art of Seeing* (New York: Kodak, 1992), 76.

Page 33—"Photography is the ideal": André Breton, *Henri Cartier-Bresson* (New York: Aperture, 1976), unpaginated.

Page 33—"Mysteriously, wonderfully": *Chuang Tzu*, trans. B. Watson, 213.

Page 33— "an occasion to demonstrate": Susan Sontag, *On Photography* (New York: Doubleday, 1989), 40.

Page 38—"Freaks was a thing": *Diane Arbus: An Aperture Monograph*, edited and designed by Doon Arbus and Marvin Israel (Millerton, NY: Aperture, 1972), 3.

Page 38—"Photography is like that": Henri Cartier-Bresson, "The Decisive Moment," in *Images of Man 2* (New York: Scholastic Magazines, 1973), 82.

Page 38—"I stood spellbound": D. Norman, *Alfred Stieglitz* (New York: Aperture, 1976), 6.

Page 39—"When the monkey trainer": *Chuang Tzu*, trans. B. Watson, 41.

Page 39—"Many people will go": V. Goodpasture, "Jerry Jacka: Capturing the Southwest's Spirit," *Photographer's Forum* (February 1994), 52.

Page 39—"Mediocre pictures may follow": Ed Feingersh, "What Makes a Good Picture?" in *The Best of Popular Photography*, ed. H. V. Fondiller, 273.

Page 39—"Seeing in terms of photography": Andreas Feininger, *The Complete Photographer: The Definitive Guide to Modern Black-and-White and Color Photography*, rev. ed. (Englewood Cliffs, NJ: Prentice Hall, 1978), 223.

Page 42—"Looking is a gift": Berner, 17.

Page 42—"The spontaneous aptitude": Angus C. Graham, in *Chuang-Tzu*, trans. A. C. Graham, 7.

Page 42—"Cook Ting was cutting up an ox": *Chuang Tzu*, trans. B. Watson, 50-51.

Page 43—"There is that moment": P. Hill and T. Cooper, *Dialogue with Photography* (New York: Cornerhouse: 1992), 80.

Page 43—"The emotion is one": George DeWolfe, "Photography and Reality: Intuitive Solutions in Image-Making," *View Camera* (March/April 1995), 3.

Page 43—"First you must lose": Henri Cartier-Bresson [Quote], *Modern Photography* (October 1988), 94.

Page 48—"So the sage": *Chuang Tzu*, trans. B. Watson, 75.

Page 48—"embody to the fullest": Ibid., 97.

Page 48—"taking pictures of bizarre types": Cecil Beaton and Gail Buckland, *The Magic Image: The Genius of Photography* (London: Pavilion, 1989), 48.

Page 48—"Alone, the Surrealist wanders": Peter Galassi, *Henri Cartier-Besson: The Early Work* (New York: Museum of Modern Art, 1987), 52.

Page 49—"Taking pictures is savoring": Marc Riboud, *Marc Riboud: Photographs at Home and Abroad*, trans. I. M. Paris and with an introduction by C. Roy (New York: Abrams, 1988), unpaginated.

Page 49—"For the camera": Ken Ruth, "Ken Ruth," *Camera & Darkroom* (January 1993), 46.

Page 49—"decisive moment": Henri Cartier-Bresson, *The Decisive Moment* (New York: Simon & Schuster, 1952), unpaginated.

Page 58—"Watching as things arrange": Benjamin Hoff, "The Camera and the Mind," *The Way of Life: At the Heart of the Tao Te Ching* (New York: Weatherhill, 1981), 83.

Page 58—"Leap into the boundless": *Chuang Tzu*, trans. B. Watson, 49.

PART II: RECONSTRUCTING REALITY

Page 61—"Photography is the ideal": The Editors of Eastman Kodak Company, *More Joy of Photography: 100 Techniques for More Creative Photography* (Reading, MA: Addison-Wesley, 1981), 10.

Page 61—"I photograph to see": *Photography Speaks*, ed. B. Johnson (New York: Aperture, 1989), 96.

Page 61—"'A photograph,' it has been said": Ibid., 24.

Page 62—"One of the magical things": M. J. Rodriguez, "Grant Mudford: Finding His Niche in the Fine Arts World," *Photographer's Forum* (May 1993), 43.

Page 62—"It's hard to imagine": Luis Buñuel, *My Last Sigh*, trans. A. Israel (New York: Random House, 1984), 33.

Page 68—"Toulouse-Lautrec once exhibited": Jeff Berner, *The Photographic Experience* (New York: Doubleday, 1975), 50.

Page 68—"Smith's Minamata photographs": Susan Sontag, *On Photography* (New York: Doubleday, 1989), 106.

Page 69—"A road is made": *The Complete Works of Chuang Tzu*, trans. Burton Watson (New York: Columbia University Press, 1968), 40.

Page 69—"wander in the Great Void": Ibid., 244.
Page 69—"Once a photographer": Andreas Feininger, *The Complete Photographer: The Definitive Guide to Modern Black-and-White and Color Photography*, rev. ed. (Englewood Cliffs, NJ: Prentice Hall, 1978), 224.
Page 72—"When out photographing": "A Photographic Portfolio by Chip Forelli," *LensWork Quarterly* (Winter 1996-97), 16.
Page 72—"instead of seeing the horseness": Derek Doeffinger, *The Kodak Workshop Series: The Art of Seeing* (New York: Kodak, 1992), 18.
Page 73—"Changing lenses causes": Berner, 27.
Page 77—"Photographs can also challenge": The Editors of Eastman Kodak Company, 12.
Page 77—"an ordinary fact": Peter Galassi, *Henri Cartier-Bresson: The Early Work* (New York: The Museum of Modern Art, 1987), 35.
Page 77—"details, framed and dismembered": Ibid., 35.
Page 77—"applied the principle": Ibid., 35.
Page 80—"Something experienced is": Abraham Maslow, *The Psychology of Science: A Reconnaissance* (New York: Harper & Row, 1966), 89.
Page 80—"improbable meanings": Galassi, 36.
Page 80—"incorporating the artificial technique": Ibid., 37.

PART III: BARRIERS TO SEEING

Page 83—"In all things": *The Complete Works of Chuang Tzu*, trans. Burton Watson (New York: Columbia University Press, 1968), 300.
Page 83—Abraham Maslow's list: Abraham Maslow, *The Psychology of Science: A Reconnaissance* (New York: Harper & Row, 1966), 27-29.
Page 83—"In photography, it is he": Andreas Feininger, *The Perfect Photograph* (Garden City, NY: Amphoto, 1974), 136.
Page 84—"Photographers who identify": Ibid., 136.
Page 84—"catch life": P. Hill and T. Cooper, *Dialogue with Photography* (New York: Cornerhouse, 1992), 90.
Page 85—"The Americans who arrived": Ibid., 90.
Page 85—"It is essential": Henri Cartier-Bresson, *The Decisive Moment* (New York: Simon & Schuster, 1952), unpaginated.
Page 88—"Even the simplest thing": D. D. Conrad, "Ruth Bernhard," *Camera & Darkroom* (May 1994), 31.
Page 88—"I am the village idiot": P. Hill and T. Cooper, 87.
Page 88—"By these labels": Frederick Franck, *The Zen of Seeing: Seeing/Drawing as Meditation* (New York: Random House, 1973), 4.
Page 88—"to see we must forget": F. Patterson, *Photography and the Art of Seeing* (New York: Van Nostrand Reinhold, 1979), 10.
Page 88—"Don't ask for a verbal": Ibid., 58–59.
Page 89—"The inexpressive is": Franck, 115.
Page 89—"The so-called 'rules'": Michael Freeman, *Achieving Photographic Style* (New York: Quarto Publishing, 1992), 32.
Page 92—"A way of certifying": Susan Sontag, *On Photography* (New York: Doubleday, 1989), 9.
Page 92—"It's a strange thing": P. Hill and T. Cooper, 336.
Page 93—"Complicated equipment and light": Henri Cartier-Bresson, *The Decisive Moment* (New York: Simon & Schuster, 1952), unpaginated.
Page 93—"It is not even difficult": Freeman, 71.
Page 93—"George Rodger, a highly regarded": Ibid., 71.
Page 93—"the click that kills": Jeff Berner, *The Photographic Experience* (New York: Doubleday, 1975), 80.
Page 93—"When making a picture": Ibid., 80.
Page 94—"I'll simply put my camera": J. D. Marston, "The Waiting," *LensWork Quarterly* (Spring 1994), 31.

Page 94—"Sometimes I have taken": *Robert Rauschenberg: Photographs* (New York: Pantheon, 1981), unpaginated.
Page 94—"We are so bombarded": Patterson, 10.
Page 95—"Experience has shown": Feininger, *The Perfect Photograph*, 132.
Page 95—"The eyes, under the": Ibid., 132.
Page 98—"represent a subtle trap": Berner, 17.
Page 98—"First, gather seventy-five": Bryan Peterson, *Learning to See Creatively* (New York: Amphoto: 1988), 47.
Page 98—"head out the door": Ibid., 47.

PART IV: TAOISTIC CAMERAWORK: METHOD AND BEYOND

Page 101—"The bells and stones": *The Complete Works of Chuang Tzu*, trans. Burton Watson (New York: Columbia University Press, 1968), 128.
Page 101—"Aesthetics is for the artists": W. Nisker, *Crazy Wisdom* (Berkeley, CA: Ten Speed Press, 1990), 90.
Page 101—"There is no other art": P. Hill and T. Cooper, *Dialogue with Photography* (New York: Cornerhouse, 1992), 186.
Page 101—"There should be a visual": Ibid., 68.
Page 102—"I don't think you can": Ibid., 63.
Page 102—"You can't teach art": Duane Michals, "The Mind of Duane Michals, *LensWork Quarterly* (Spring 1995), 29.
Page 102—"You learn to see things": P. Hill and T. Cooper, 195.
Page 102—"A lot of education": Ibid., 126.
Page 103—"The photographer projects himself": Susan Sontag, *On Photography* (New York: Doubleday, 1989), 116.
Page 103—"If I can get them to think": Ibid., 215.
Page 103—"First, one must learn": Ibid., 36.
Page 103—"Somebody said recently": Ibid., 125.
Page 103—"Paths are made:" *Chuang Tzu*, trans. B. Watson, 166.
Page 108—"There is no way": Alan Watts, *Become What You Are* (Boston: Shambhala, 1995), 53.
Page 108—"The emperor of the South Sea": *Chuang Tzu*, trans. B. Watson, 97.
Page 109—"He who understands": Ibid., 182.
Page 109—"If the Way is made clear": Ibid., 44.
Page 109—"When I chisel a wheel": Ibid., 152–153.
Page 112—"If one really wishes": George DeWolfe, "Photography and Reality: Intuitive Solutions in Imagemaking," *View Camera* (March/April 1995), 3.
Page 113—"It is part of the photographer's job": *Photography Speaks*, ed. B. Johnson (New York: Aperture, 1989), 60.
Page 113—"When contemplated through": Jeff Berner, *The Photographic Experience* (New York: Doubleday, 1975), 119.

PART V: THE PATH OF CONSCIOUS CAMERAWORK

Page 121—"The eye that is penetrating": *The Complete Works of Chuang Tzu*, trans. Burton Watson (New York: Columbia University Press, 1968), 300.
Page 121—"Mindfulness entails breaking": Daniel Goleman, *The Meditative Mind: The Varieties of Meditative Experience* (Los Angeles: Jeremy P. Tarcher/Perigee Books, 1988), 20.
Page 122—"I have particularly noticed": Jeremy Hayward, "First Thought," *Tricycle: The Buddhist Review* (Spring 1995), 27. Also appears in J. Hayward and K. Hayward, *Sacred World: The Shambhala Way to Gentleness, Bravery, and Power* (Boston: Shambhala, 1998), 138.

Page 122—"When you take photographs": Jeremy Hayward, "First Thought," *Tricycle: The Buddhist Review* (Spring 1995), 27.
Page 122—"use the artist's": Abraham Maslow, "Living in the World of Higher Values," in *Future Visions: The Unpublished Papers of Abraham Maslow*, ed. E. Hoffman (Thousand Oaks, CA: Sage, 1996), 76.
Page 122—"preconceptions, expectations, and theories": Ibid., 76.
Page 122—"Enlarge the object": Ibid., 76.
Page 122—"The art of mindful photography": "The Art of Mindful Photography: Workshop with John Daido Loori," *Mountain Record*, 2 (15–16) (1983), 6. [Announcement]
Page 122—"paying attention in a particular way": Jon Kabat-Zinn, *Wherever You Go, There You Are: Mindful Meditation in Everyday Life* (New York: Hyperion, 1994), 4.
Page 123—"the forces that work against": Ibid., 8.
Page 123—"Seeing is perception": Advertisement in 1979 for forthcoming book "The Art of Mindful Photography" by John Daido Loori.
Page 123—"sometimes the pictures disappear": Henri Cartier-Bresson, "The Decisive Moment." In *Images of Man 2* (New York: Scholastic Magazines, 1973), 74.
Page 123—"observe themselves as observers": D. Doeffinger, *The Kodak Workshop Series: The Art of Seeing* (New York: Kodak, 1992), 18.
Page 128—"We are not interested": Beaumont Newhall, *Focus: Memoirs of a Life in Photography* (Boston: Bullfinch, 1993), 122.
Page 128—"It may seem ironic": Duane Preble, personal communication, July 2000.
Page 128—"I am not interested": Alexander Haas, *Ernst Haas in Black and White*, photographs selected and edited by J. Hughes & A. Haas; introduction by J. Hughes (Boston: Little, Brown, 1992), 17.
Page 128—"The ten thousand things": *Chuang Tzu*, trans. B. Watson, 236.
Page 129—"What ordinary people do": Ibid., 191.
Page 129—"Perfect action is": Ibid., 247.
Page 129—"which seems to be telling us": Gerald G. May, *Simply Sane: Stop Fixing Yourself and Start Really Living* (New York: Paulist Press, 1977), 90.
Page 130—"The peaker learns surely": Abraham Maslow, *Religions, Values, and Peak-Experiences* (New York: Penguin, 1970), 75.
Page 130—"He who considers wealth": *Chuang Tzu*, trans. B. Watson, 162.
Page 131—"Much as I appreciate": Lin Yutang, *The Importance of Living* (New York: John Day, 1937), 366.
Page 131—"I am living an end-life": T. G. Harris, "Editorial: Abe Maslow (1908-1970)," *Psychology Today* (August 1970), 16.

EPILOGUE: SEEING BEYOND SEEING

Page 133—"The ten thousand things": *The Complete Works of Chuang Tzu*, trans. Burton Watson (New York: Columbia University Press, 1968), 288.
Page 133—"The secret of the Tao": Lao-tzu, *The Way of Life: At the Heart of the Tao Te Ching*, ed. & trans. Benjamin Hoff (New York: Weatherhill, 1981), 49.
Page 134—"Seeing the smallest dewdrop": John Shaw, *Focus on Nature* (New York: Amphoto, 1991), 33.
Page 134—"Master Tung-kuo asked": *Chuang Tzu*, trans. B. Watson, 240–241.
Page 134—"Leap into the boundless": Ibid., 49.